# D-DAY
## IN PHOTOGRAPHS

### ANDREW WHITMARSH

The
History
Press

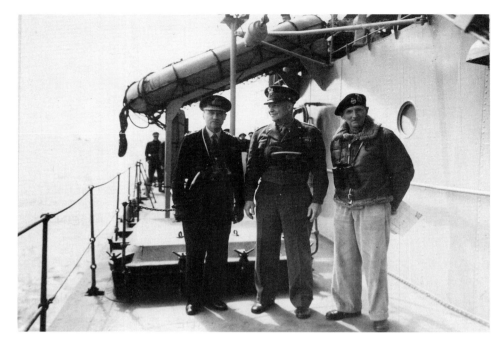

Three key Allied commanders for D-Day: (left to right) Allied Naval Commander, Admiral Sir Bertram Ramsay; Supreme Allied Commander, General Dwight Eisenhower; Allied Ground Forces Commander, General Sir Bernard Montgomery. They are on board the minelayer HMS *Apollo*, just off the coast of Normandy on 7 June 1944.

First published 2009
This edition published 2012

The History Press
The Mill, Brimscombe Port
Stroud, Gloucestershire, GL5 2QG
www.thehistorypress.co.uk

British Library Cataloguing in Publication Data.
A catalogue record for this book is available from the British Library.

ISBN 978 0 7524 7479 3

Typesetting and origination by The History Press
Manufacturing managed by Jellyfish Print Solutions Ltd
Printed in India.

*Front cover:* A British Royal Navy landing craft carries US Rangers to their ship at Weymouth before D-Day. (Conseil Régional de Basse-Normandie/US National Archives)
*Back cover:* Landing craft and ships unload their cargoes at Omaha Beach after D-Day. (Conseil Régional de Basse-Normandie/US National Archives)

# CONTENTS

# FOREWORD

## By Viscount Montgomery of Alamein CMG CBE

Following the evacuation from Dunkirk in 1940 and the defeat of France, Britain found herself on her own for the Blitz and the Battle of Britain. With the entry of the Soviet Union in June 1941, followed by the United States that December, the tide slowly started to turn. However, it became clear that the war could only end with the return of Allied forces to N.W. Europe. At the end of 1943 General Eisenhower was appointed Supreme Allied Commander, with my father as Ground Forces Commander. Apart from the British, the Allied Force was principally from the USA and Canada, with smaller contingents from a number of other countries. The whole of the south of England was a restricted area with many military camps, and every harbour bursting with naval ships and landing craft.

The invasion of the north coast of France took place on 6 June 1944, initiating the final stage of the Second World War. It was the largest single military operation in the history of warfare, representing a massive effort in planning, co-ordination, leadership, courage and dedication to duty. The ensuing Battle of Normandy was concluded at the end of August but, due to supply problems, the war continued into 1945 and was finally brought to a conclusion in early May 1945 with the surrender of the German Forces at Luneburg Heath.

Andrew Whitmarsh, whose earlier book tells the story of Portsmouth at War, has now gone further by producing *D-Day in Photographs*. Drawn from material in the D-Day Museum where he is the Curator and Military History Officer, it gives a vivid account of how the campaign developed from the planning stage to D-Day itself, the Battle of Normandy and the end of the war in Europe.

We study war not to glorify it. Quite the contrary; we study war as an illustration of folly, so that lessons may be learnt and the terrible toll on human life and material destruction can be avoided in the future. Unfortunately it would appear that we still have much to learn. This book may help in that process.

Montgomery of Alamein
London
March 2009

# INTRODUCTION

'D-Day' is a phrase of military origins that has entered into everyday language as meaning a moment of decisive action. Formerly a generic term for the day on which a military operation starts, in the context of warfare, the expression now refers in particular to 6 June 1944, the first day of the Normandy Landings. D-Day truly was a turning point in world history. It began the final stage of the destruction of the Nazi regime in Germany, the liberation of occupied Europe and the end of the Second World War.

Many books have been written about D-Day. This volume takes a fresh look at this period in our history, illustrated with photographs, maps, documents, drawings and other material from the extensive archives of the D-Day Museum at Portsmouth, much of which is previously unpublished. The D-Day Museum is the UK's only museum with the sole aim of telling the story of the Normandy Landings, and is also the home of the unique Overlord Embroidery (examined in detail later).

Although the overall story of D-Day is widely known, there are still aspects that have not yet been fully explored by historians. This book aims to put D-Day in context, but the limitations of space do not permit the mention of every unit that took part in the fighting in Normandy, or indeed every stage of the battle.

Some of the images in this book were produced for official purposes, while other people carried their own personal camera (or sketchbook) in their infantryman's rucksack, tank turret or landing craft bridge. The author would like to thank the photographers and artists who produced the illustrations used here, often in difficult and dangerous conditions, which enable us to gain greater understanding of this period.

This book is respectfully dedicated to the veterans of D-Day and the Battle of Normandy.

Andrew Whitmarsh
www.ddaymuseum.co.uk

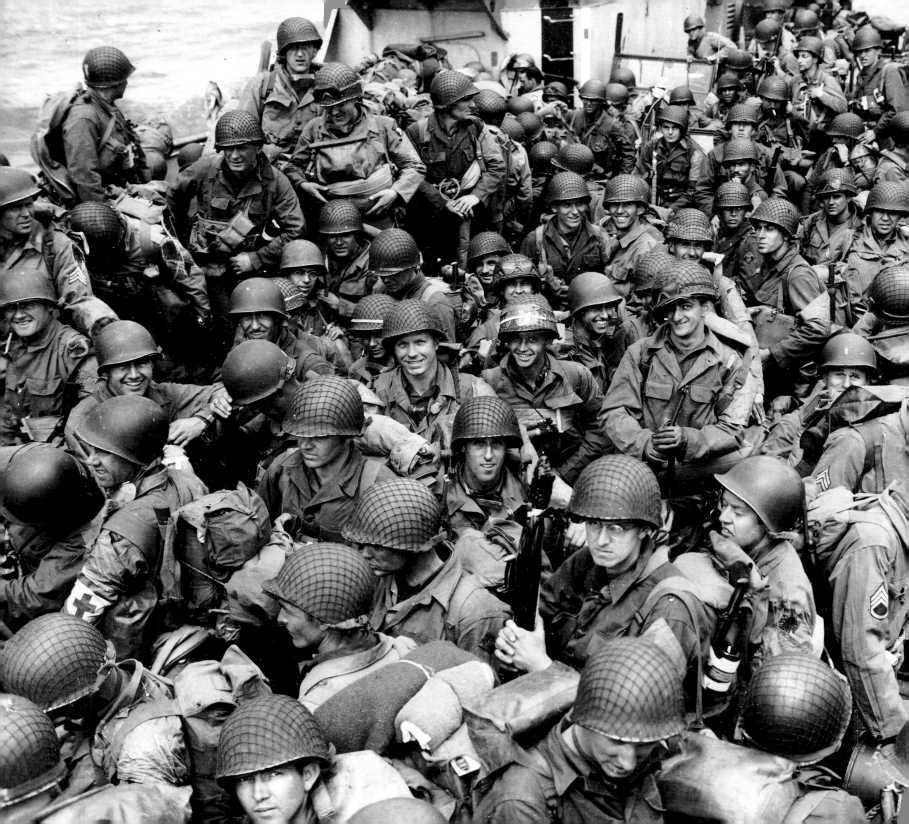

# one

# 'WE SHALL GO BACK': PREPARATIONS FOR D-DAY

D-Day – the Normandy Landings on 6 June 1944 – was a turning point in the Second World War. However the day itself, and the subsequent Battle of Normandy, can only be understood in the context of wider events, starting with the aftermath of the previous global conflict.

After its defeat in the First World War of 1914-18, Germany experienced a turbulent period of internal disturbances and ineffectual politics, financial impositions in the form of war reparations, hyper-inflation and unemployment. The rise to power of Adolf Hitler's Nazi party ended in 1933 with Hitler becoming Chancellor. After re-arming Germany (which after the First World War had been restricted to an army of 100,000 men), Hitler used propaganda, deceit and the threat of military force to bring Austria and Czechoslovakia into the new German state. The German invasion of Poland on 1 September 1939 led to France and Britain declaring war on Germany two days later, although neither could save Poland from occupation by Germany and the Soviet Union.

In France, British troops waited alongside their French allies for a German attack. The following months of inactivity were known as the Phoney War. The lull ended in April 1940 with the Blitzkrieg, named from the German for 'lightning war', reflecting the speed of the German attacks. Denmark and Norway fell to the Nazis. In the UK, the discredited administration of Neville Chamberlain was replaced on 10 May 1940 by a coalition government led by Winston Churchill. That same day saw the beginning of the German invasion of France, Belgium and the Netherlands. By 3 June the fighting in France

American soldiers bound for Utah Beach in Normandy after D-Day. They include soldiers of 4th Infantry Division. For all the Allies' massive quantities of equipment, ultimately it was infantrymen like these who had to go forward and occupy enemy territory, as they have done since mankind's first conflicts.

was at an end. 338,000 British, French and other troops were evacuated to the UK from Dunkirk and other ports. Soon after, Churchill promised in Parliament that 'We shall go back', but it would be four years before this promise was carried out in the form of D-Day.

From this point onwards there was little doubt that Britain could only win the war by launching an invasion of German-occupied continental Europe. But in late 1940 the British had no Allies except the Commonwealth and were in no position to do so. A series of military campaigns took place over the next four years, in each of which anything other than an Allied victory could have put D-Day in doubt. The immediate threat was of a German invasion of the UK. The Battle of Britain, lasting from June to September 1940, saw the Royal Air Force (RAF) prevent the Luftwaffe (German air force) from establishing the conditions for a seaborne invasion (namely, air superiority). The Luftwaffe turned instead to launch the bombing raids of the Blitz on British cities.

The middle of 1940 also saw the beginning of the main phase of the Battle of the Atlantic. The Germans sought to prevent the movement of supplies to the UK by sea, particularly from the USA which at this point had not yet entered the war. The main threat to shipping came from U-boats (German submarines). By 1944 the Allies had won the battle, which was a pre-condition to launching D-Day. The huge quantities of American men and munitions required for the landings had to be brought safely across from the USA (an American armoured division required forty ships to carry it across the Atlantic, for example). Had the situation not been resolved by 1944, continued U-boat attacks would have worsened the already severe delays that did occur in supplying Allied troops during the subsequent Battle of Normandy.

Several key events took place in 1941. On 22 June Germany invaded her former ally, the Soviet Union, seeking her vast lands and natural resources.

# Le Courrier de l'Air

Apporté par vos amis de la R.A.F.

1942 No. 4

Distribué par les patriotes français

## M. Churchill pilote lui-même l'hydravion dans lequel il est rentré d'Amérique

# UNE MISSION HISTORIQUE EST TERMINÉE

DÉJOUANT les sous-marins allemands qui attendaient au large de New York, M. Churchill est rentré des Etats-Unis par la voie des airs. Il est arrivé à Plymouth le samedi matin, 17 janvier, après avoir traversé l'Atlantique dans un hydravion quadrimoteur des British Airways.

Pendant une partie du voyage de 5.000 km. M. Churchill, qui fut breveté pilote en 1914, pilota lui-même l'hydravion. Il fut accompagné notamment par Lord Beaverbrook, Ministre de l'Armement, l'amiral Sir Dudley Pound, chef de l'état-major naval, et Sir Charles Portal, chef de l'état-major de l'air.

A son arrivée à Londres M. Churchill fut acclamé par une foule enthousiaste. Le Roi lui adressa un message de bienvenue.

# DEUX VICTOIRES des ALLIES

## Les Russes ont pris Mojaïsk

COMMUNIQUÉ russe du 21 janvier: " Le 20 janvier, nos troupes ont continué d'avancer et de refouler vers l'ouest les troupes allemandes en leur infligeant de lourdes pertes. Nos troupes ont pris Mojaïsk."

Cette victoire de Mojaïsk, déclare d'autre part un supplément au communiqué, a contraint au recul des forces allemandes nombreuses d'environ 100.000 hommes, et considérées comme la fleur de l'armée nazie. Les survivants de Mojaïsk se trouvent maintenant en danger d'encerclement près de Vereya, localité située à 21 kilomètres au sud-est de Mojaïsk.

Plus au sud, les Russes poussent vers Yelnia et Smolensk en suivant le chemin de fer de Kalouga à Smolensk. Pendant ce temps, les opérations dans le nord du secteur de Moscou, particulièrement dans la région de Rzev, ne sont nullement ralenties.

Entre ces deux poussées qui convergeront peut-être bientôt sur Vyazma ou Smolensk, les pénétrations russes dépassent largement les lieux indiqués par les communiqués. Il ne s'agit pas seulement de guérillas, mais d'infiltrations profondes d'unités russes: chars légers, skieurs et cavalerie— jusqu'à proximité ou même à l'intérieur de positions que les Allemands considéraient encore il y a trois semaines comme sûres et loin des premières lignes.

## A HALFAYA, UNE NOUVELLE REDDITION ALLEMANDE

LES troupes britanniques, françaises libres et polonaises ont occupé samedi Halfaya, la dernière forteresse

A British propaganda leaflet dropped on occupied France. The main article refers to the Anglo-American discussions at the first Washington Conference, December 1941–January 1942. The photograph shows Churchill at the controls of the flying boat in which he crossed the Atlantic after his 'historic mission' (in the words of the leaflet).

On 7 December Japan entered the war with an attack on the US fleet at Pearl Harbour, Hawaii. Germany immediately declared war on the USA as well. Hitler's regime now faced the Soviet Union and the USA, the world's greatest land power and industrial power respectively.

The United Kingdom, the USA and the Soviet Union were now Allies. Each had their military strengths and weaknesses, and also their own particular opinions on how the war should be brought to a conclusion. Soviet leader Joseph Stalin was naturally keen for the British and Americans to attack German-occupied Western Europe at the first opportunity, to relieve the pressure on his troops to the east. The scale of the fighting on the Eastern Front between Germany and the Soviet Union is sometimes overlooked. At the end of June 1944 the Soviet Union launched Operation Bagration, a major offensive with 1.7 million soldiers, over ten times the number of Allied troops who landed on D-Day.

In December 1941, at the Arcadia conference in Washington, the USA and Britain agreed on the principle of 'Germany First'. In other words, the main Anglo-American war effort would be directed against Germany in Europe rather than Japan in the Pacific. The war against Japan was still a thorny issue between the two Allies. Some American leaders argued that America's main interests were in the Pacific, and that the fighting in Europe should take second place. The two theatres of war were in competition for many of the same resources, such as the landing craft and ships needed both for D-Day and in the Pacific.

The US urged for a landing in Europe as soon as possible, preferably before the end of 1942. In the UK there was also public pressure, with the favoured slogan of 'Second Front Now!' With several years experience of fighting the Germans, the British government and armed forces took a more measured approach. They believed that more time was required to assemble and train the Allied forces required for such a huge operation. The Americans were persuaded to join British and Commonwealth troops fighting in the Mediterranean theatre. In October 1942 the British Eighth Army, led by Lieutenant General (later Field Marshal Sir) Bernard Montgomery, defeated Field Marshal Erwin Rommel's German forces at El Alamein in Egypt, and the following month saw Anglo-American landings in Morocco and Algeria. With the expulsion of German forces from North Africa, an attack from the south against Germany and her ally Italy became possible.

Meanwhile, preparations for the Anglo-American landings in Europe were underway, even if a date had not yet been set. Specialist units, equipment and tactics were developed which would play vital parts in the landings. Following the successful German use of glider and parachute troops in the 1940 campaigns, Britain and the US began creating airborne forces in 1940-41 which in time would include the British 6th Airborne and US 82nd and 101st Airborne Divisions, all of which would play key roles on D-Day. The British Commandos and the US Rangers were set up as elite raiding and assault troops.

Specialist landing craft and ships would be required for a major amphibious operation. Many of the landing craft and landing ships used on D-Day originated with British innovations from before the war, or from the early war years. An example was the British 'Landing Craft, Assault' (LCA), designed to carry thirty-five troops. The American equivalent was the 'Landing Craft, Vehicle and Personnel' (LCVP), which was nicknamed the *Higgins Boat* after its New Orleans designer, Andrew Higgins. One of the most important vessels was the 'Landing Ship, Tank' (LST), which could land twenty Sherman tanks directly onto a beach. American industrial capacity was vital in developing and producing sufficient quantities of landing craft and ships for D-Day.

In October 1941 the UK's Combined Operations Command received a new commander, Lord Louis Mountbatten. Under his control, the Command turned from launching minor raids to preparing for the invasion of the whole of German-occupied Europe. Mountbatten's command also saw the development of two great engineering feats, the Mulberry Harbours (artificial harbours) and PLUTO (Pipe Line Under The Ocean), which will be described later.

On 19 August 1942 Combined Operations launched what has become known as the Dieppe Raid. This was a major attack by around 5,000 Canadian and 1,000 British troops on the French port of Dieppe. The Allied force suffered heavy losses and in many places was pinned down by German fire. The survivors were withdrawn by sea later that day. The operation has often been credited with teaching the Allies useful lessons for D-Day, although many of these lessons were already known. The raid did demonstrate that the Germans were likely to defend ports so well that the Allies could not depend on capturing them quickly. It also indicated the need for two factors that were missing from the Dieppe campaign: the element of surprise, and bombardment by aircraft and warships before the troops landed.

When they landed on D-Day the first waves of infantry would be terribly exposed. A single enemy machine gun or bunker could block the advance of a much larger number of soldiers. Consequently a variety of specialised British armoured vehicles were designed for D-Day. Known as the 'Funnies', they were incorporated into the 79th Armoured Division. Some were equipped to deal with enemy defences such as pillboxes or minefields, while

SOVIET WAR NEWS WEEKLY—Thursday, 20th August, 1942

# Soviet War News

## weekly

No. 31    AUGUST 20 1942

THREEPENCE

## FORWARD
### *from the*
## MOSCOW
## TALKS !

★ *by a* ★
**Special Correspondent**

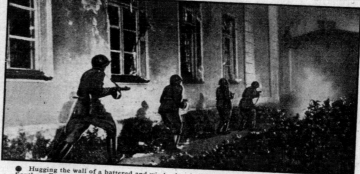

● Hugging the wall of a battered and windowless building, Red Army machine-gunners on the Southern Front advance on an "inhabited point." The village was shortly afterwards recaptured by the advancing Soviet forces. This picture, wired to "Soviet War News Weekly" direct from Moscow, was taken in the flash from a bursting shell.

THE Moscow negotiations have taken place at a moment of great historical significance to the peoples of the world.

The German offensive in the Soviet south continues. All reports from the front agree that the Nazi Command is displaying a suicidal attitude with regard to losses of man-power. Picked armoured divisions are thrown into battle again and again on every sector of the front, whatever the cost. What remains of Germany's old élite troops is concentrated there. It

they are determined to use it fully—against the old "Enemy No. 1."

It is not only Caucasian oil which Hitler covets—it is a jumping-off board against Britain. "The road to London lies through Russia." The Nazis are aware that powerful Anglo-American forces are being prepared against them beyond the

## Hitler Plans to Turn West

in time against the expected people's revolt on the Continent. Quisling, Degrelle and Mussert,

In his latest article in *Das Reich*, entitled "Concentration of Forces," Goebbels wrote:

"*Germany is compelled to concentrate all her forces in the east since the issue of the war will be decided in the battlefields of the east. He who wins there will win in general.*"

He continued:

"*We have to reconcile ourselves to the painful wounds that are being inflicted upon*

Produced in the UK to promote the Soviet cause, this newspaper had a circulation of 50,000. At the Moscow talks between Churchill, Stalin and Roosevelt's envoy Averell Harriman, Stalin was told that there could be no Second Front in 1942. The second headline suggests the consequences of Anglo-American inaction.

others could bridge a gap that other vehicles could not cross. Many of the Funnies were variants of the Churchill tank, known as the AVRE (Armoured Vehicle Royal Engineers).

There were also the unique amphibious 'DD' tanks, fitted with a canvas screen that enabled the tanks to float. These initials stood for Duplex Drive which referred to the fact that the tanks had two methods of propulsion, one for moving on land and one for water. The DD tanks would travel the final distance to the beach under their own power rather than in a landing craft, so they would appear unexpectedly just before the main invasion force.

A vital part of the preparations for D-Day was Operation Bolero, the assembly of US forces in the UK. By mid-1943 there were 238,000 American troops in the UK; by May 1944, just before D-Day, this number had risen to 1.5 million.

At the January 1943 Casablanca conference the British secured American agreement to a landing on the Italian island of Sicily for that July. Churchill and US President Franklin Roosevelt agreed to create a joint Anglo-American staff to begin the planning for D-Day. The name of this organisation and of its head, Lieutenant-General Frederick Morgan, was COSSAC, standing for Chief of Staff to the Supreme Allied Commander (Designate). COSSAC had to cover every aspect of D-Day from strategic questions such as the choice of landing site to obtaining details on individual German gun positions.

COSSAC's task built on the previous work of the Inter-Services Topographical Department (ISTD). The ISTD had found that there was very little detailed information about the coasts of Europe. A public appeal on BBC radio for postcards and holiday snaps covering the whole of Europe brought in 10 million items from across the UK, some of which gave useful information. Reconnaissance aircraft flew up and down the coast from Belgium to the Bay of Biscay, photographing it from a variety of angles.

Information was also received from members of the Resistance in France, who risked arrest and even death at the hands of the occupying Germans to collect it. The French Resistance could provide useful clues on the construction methods of a concrete bunker, or inform the Allies of the movements of German units. The Resistance were supported by Allied organisations such as the British SOE (Special Operations Executive).

COSSAC's key recommendation was the site where D-Day should take place. The invasion forces needed flat beaches where large numbers of troops could land. The location had to be close enough to the UK that fighter aircraft based there could protect the landing site. It also had to be fairly close to the UK for the rapid delivery of supplies and reinforcements by sea. The area inland had to be suitable for creating a defendable beachhead, and then for the Allied troops to break out. Finally, the landing site needed to be on a reasonably direct route into the heart of Germany.

Normandy and the Pas de Calais (northern France) both fitted these calculations, but the German fortifications in Normandy were not as strong. The Allies felt the Pas de Calais was too obvious a landing site, as it was the one with the shortest sea crossing, via the Straits of Dover, and offered the most direct route into Germany.

In May 1943, at the Trident conference in Washington, it was agreed that D-Day would take place on 1 May 1944. Prior to this the Allies would invade mainland Italy. The Italian landings took place in September 1943, but the invasion of German-occupied Italy proved to be a hard fight. The Americans often regarded the Allied campaigns in North Africa and Italy as distractions from the final defeat of Germany. Yet they provided the Allies with experience in amphibious landings, and made the American armed forces more familiar with German tactics and equipment.

At the end of 1943, US General Dwight Eisenhower was informed that he would be in command of Operation Overlord, the code name given to the Normandy landings. Although on D-Day the greater part of the Allied forces were from the United Kingdom and the Commonwealth, over time the US forces would become the largest component, so it was logical to have an American in overall command. 'Ike', as Eisenhower was widely known, had commanded the Allied landings in North Africa, Sicily and Italy in 1942-43. During these campaigns he had shown great ability in co-ordinating the various Allied forces. His role was sometimes political as much as it was military, and for D-Day he would command forces from Belgium, Australia, Czechoslovakia, France, Greece, Poland, the Netherlands, New Zealand and Norway, as well as Britain, Canada and the USA. Notable among these national forces were General Charles de Gaulle's Free French (French people who did not agree with their country's surrender to the Germans in June 1940, and were determined to continue fighting).

Eisenhower's chief of staff was Major General Walter Bedell Smith, and his deputy was British Air Chief Marshal Sir Arthur Tedder. The position of Allied naval commander was naturally a vital role in an amphibious landing, and this post was given to Admiral Sir Bertram Ramsay who would command Operation Neptune (the code name for the naval aspects of the landings). He had co-ordinated both the 1940 Dunkirk evacuations and the 1942 North Africa landings. Air Chief Marshal Sir Trafford Leigh-Mallory was chosen to lead the Allied Expeditionary Air Force – in other words, the British and American tactical air forces in Britain.

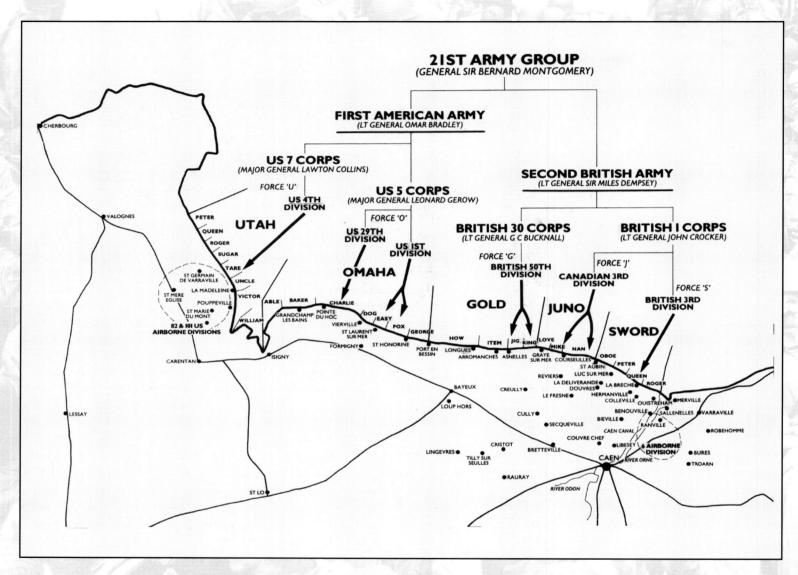

Map showing the overall plan for D-Day, and the main Allied units to land at each of the five beaches.

A key role on D-Day and in the subsequent months was that of the Allied ground forces commander, General Sir Bernard Montgomery. Although he had a track record of victories, 'Monty' (as he was nicknamed) did not always enjoy harmonious relations with all the other Allied commanders. On D-Day the Allied ground forces of 21st Army Group under General Montgomery comprised of two armies: the US First Army (Lieutenant General Omar Bradley) and the British Second Army (Lieutenant General Miles Dempsey).

The Allied commanders re-examined the COSSAC plan which was based on three beaches, thirty miles wide in total, with three divisions in the initial landings and two more in support. Montgomery and Eisenhower argued that a larger force was necessary: five divisions landing on five beaches, sixty-one miles across, with four more divisions in support. The new additions were Utah and Sword, beaches on each side of the initial landing area. These would enable the Allies to strike out more rapidly for the port of Cherbourg and the city of Caen respectively. Although this rise in troop numbers would result in a more powerful landing force, an extra month would be needed to gather additional naval vessels.

Allied strategy in Normandy was controversial at the time, and the debate has since continued in many books. There is insufficient space here to repeat the opposing arguments, but in essence Montgomery's plan was that the Anglo-Canadians would push forward on the eastern side of the beachhead, drawing the German reserves onto that flank, thus allowing the Americans to break out in the west and advance into Brittany; then the whole Allied army would advance on a broad front and push the Germans back.

Many troops taking part in D-Day had spent years in training. They frequently practised amphibious landings, first on a small scale and then with units of increasing size. On 28 April 1944 German E-boats (fast attack craft) surprised a convoy of LSTs on their way to practice landings at Slapton Sands in Devon, known as Exercise Tiger. Two LSTs were sunk and a third badly damaged, killing 749 men of the US 4th Division. In early May a further series of major D-Day rehearsals, code name Fabius, took place for each landing force.

Air power would play a vital role on D-Day and during the subsequent Battle of Normandy. If the Allies could not at least gain the upper hand in the air then they would be much less likely to surprise the enemy, and the invasion could face serious casualties and delays due to German air attacks.

The raids into Germany by RAF Bomber Command and its American equivalent, the US 8th Army Air Force, began to wear down the strength of the German air force. Eisenhower had the British and American heavy bombers placed under his command. These aircraft were used in the Transportation Plan, a systematic attack on the French railway network with the aim of slowing the flow of German reinforcements to Normandy following D-Day. This bombing reduced French railways to 30–40 per cent of their 1943 capacity.

Laying the foundations for D-Day took its toll on Allied air forces, and in April and May 1944 they lost nearly 12,000 men and over 2,000 aircraft. The Allies were also very worried about the likely French civilian casualties in these bombing raids, but the Free French government-in-exile accepted that some civilian deaths in such attacks would be unavoidable in order to achieve the liberation of the whole country.

Meanwhile, in Normandy, and indeed along all the coasts of occupied Europe, the Germans were strengthening their defences. The Allies could choose where to land, whereas the Germans had to defend everywhere. Since 1942 the Germans had been building fortifications along the coasts of Western Europe, known as the Atlantic Wall. This was not a single row of defences but several lines of bunkers, gun positions and minefields. Due to the fragmented command structure of the German armed forces, the Atlantic Wall was not built in a coherent way. Different organisations, such as the civilian construction force (the Todt Organisation), and the German army and navy, each separately built what defences they thought were needed.

Field Marshal Erwin Rommel played a key role in the construction of these defences. He was appointed to inspect the coastal defences of Western Europe, and was then put in command of Army Group B in northern France, Belgium and the Netherlands. Yet even he could not order the Todt Organisation to build specific defences, and consequently had to use soldiers for construction work instead. This in turn decreased his soldiers' military efficiency since less time could be spent on training, which was particularly significant as a proportion of them were young recruits, not seasoned soldiers.

By D-Day there were some 500,000 obstacles on the beaches designed to halt or sink landing craft. The number of mines in the coastal defences had been tripled on Rommel's orders. Inland, wooden posts linked by wire (nicknamed 'Rommel's asparagus') were set up as obstacles in fields where gliders might land. However, priority in the construction of defences had been given to the Pas de Calais. In and around Normandy the most effective fortifications had been built around ports such as Cherbourg and St Malo, since the Germans expected the Allies to try to seize a port early in the landings.

The German command structure in France was complicated. Rommel's Army Group B consisted of the Seventh Army in north-west France and the Fifteenth Army in the Calais area, even further north. Yet many types of

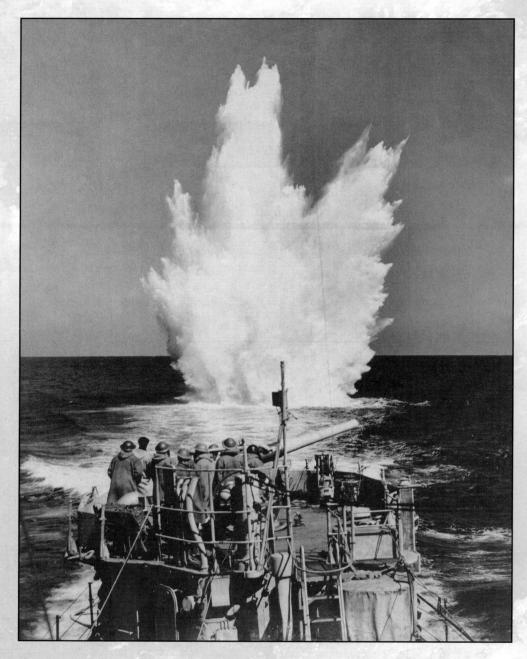

Anti-submarine depth charges explode behind a Royal Navy warship during the Battle of the Atlantic. By 1944 the Allies had won this long campaign. Any other outcome could have jeopardised the success of D-Day.

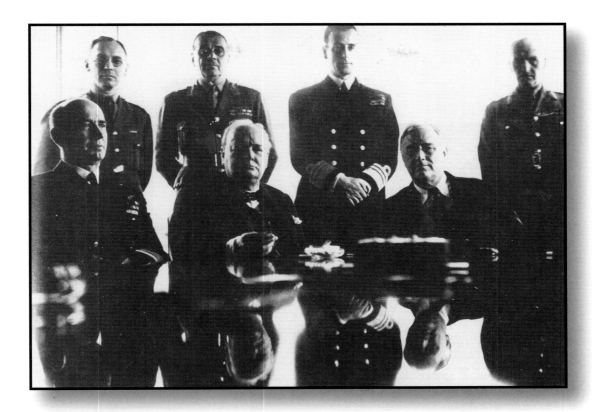

Churchill and Roosevelt met at Casablanca in January 1943. Standing between them is Vice Admiral Lord Louis Mountbatten, head of Combined Operations. Following German defeat in North Africa, the Allies decided that an invasion of Sicily was next on the agenda, further postponing D-Day. (Courtesy of Royal Naval Museum, Portsmouth)

troops, such as anti-aircraft forces or the Waffen-SS (including some of the most powerful tank units) did not come under Rommel's full authority. The only true overall command lay with Hitler, who was many miles away and would become increasingly out of touch with the reality of the situation in Normandy.

Rommel believed that the Allied troops had to be defeated as soon as they came ashore, which was the origin of his phrase describing the first day of the landings as 'the longest day' – in other words, the day that would decide the outcome of the battle. The German Commander-in-Chief West (commander of all German forces in north-west Europe), Field Marshal Gerd von Rundstedt, disagreed. He and other senior officers believed that a determined attacker would eventually break through the initial German defences, and that it would

be better to hold a mobile reserve of tanks back from the coast. However, Rommel's experience with fighting the British and Americans convinced him that Allied air power would prevent the use of large-scale reserves. The most powerful German forces potentially available to Rommel were seven panzer (tank) divisions. Hitler chose a middle path between these two arguments, and decided that four of these seven divisions would be under his personal command, and could not be moved without direct orders from him.

Despite the Allies holding advantages over the Germans in many respects, the outcome of D-Day was far from certain. The great extent of the Allied preparations should not disguide this fact: it was because the landings would be so tough that the Allies put so much effort into preparing for them.

**1**  US Marines landed on the Pacific island of Guadalcanal on 7 August 1942. Here they are using an amphibious 'Landing Vehicle, Tracked' or LVT. 40,000 US troops took six months to subdue the Japanese defenders. The Pacific campaign competed for many of the same resources as D-Day.

**2**  British troops in a Universal Carrier land in Sicily on 10 July 1943. British leaders were far keener on campaigns in North Africa and Italy than the Americans, who saw these as distractions from a direct attack on Germany through north-west Europe.

**3**  'Very raw recruits' (according to the caption by the photographer, Albert White) of the Hampshire Regiment in Somerset, early 1940. The British Army rapidly grew in size to meet wartime requirements. Many new recruits spent several years in training for D-Day.

**4**  The huge numbers of American troops (known as 'GIs') who came to the UK – with their strange customs and plentiful supplies – was sometimes referred to as the 'friendly invasion'. A group of GIs are seen here on a visit to the Isle of Wight (from an American Red Cross booklet).

**5**  After the disastrous Dieppe Raid of 19 August 1942 German aircraft dropped huge quantities of this propaganda leaflet on the UK. With many photographs of dead or captured British and Canadian troops, and wrecked equipment, it implied that the 'raid' was really a genuine invasion attempt that had failed.

**6**  Polish troops relaxing somewhere in the UK. Troops from many nations would take part in the fighting in Normandy, including those from German-occupied countries such as Poland, France and the Netherlands. Photograph taken by Tadeusz Kubisa, who served in the Polish 1st Armoured Division after escaping to France and then to the UK in 1939-40.

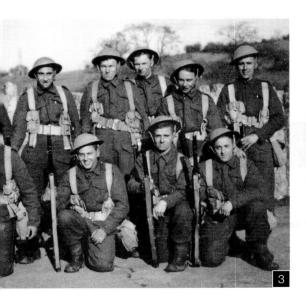

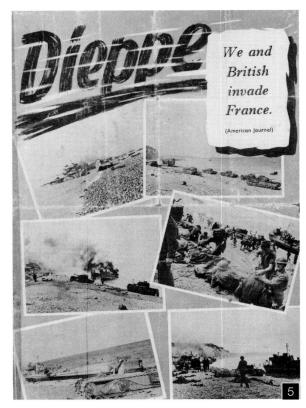

Dieppe

We and British invade France.

(American Journal)

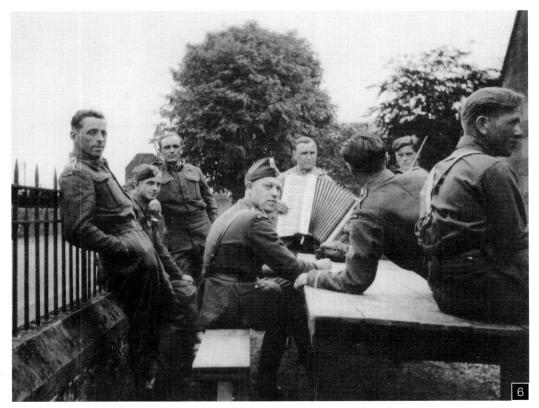

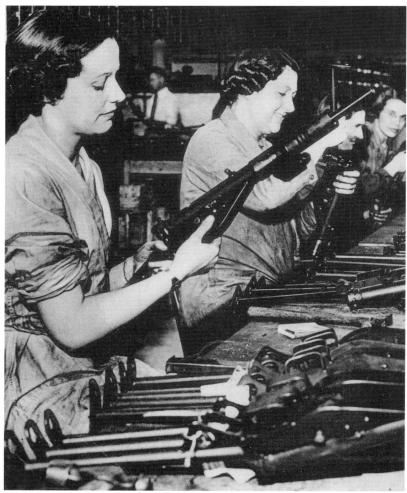

French members of No.10 (Inter-Allied) Commando, a unit formed from men who had escaped from countries occupied by the Germans. On D-Day 177 Frenchmen from this Commando landed on Sword Beach, under the command of Captain Philippe Kieffer. (© Trustees of the Royal Marines Museum)

Women assembling Sten sub-machine guns in a British factory. Munitions production, and the British war effort in general, relied heavily on women, often performing tasks that before the war were considered the domain of men.

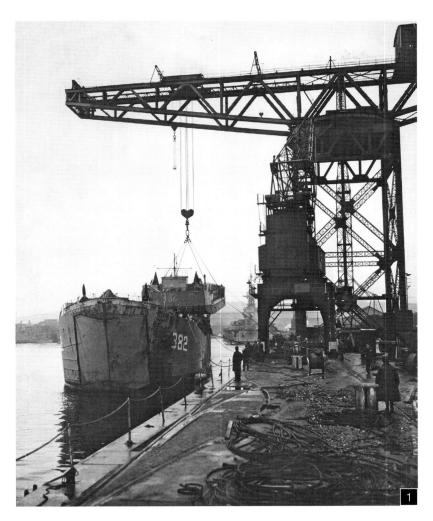

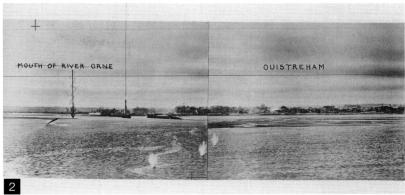

**1** A Landing Craft, Tank (LCT) being unloaded from the Landing Ship, Tank (LST) that carried it across the Atlantic from the USA, where both had been made. American manufacturing capabilities played a vital role in the Allied victory. LCT 332, shown here, was critically damaged by a mine on D-Day. (US Navy photograph)

**2** Low-level aerial photographs of the coast of northern France were prepared to aid landing craft crews on D-Day. This shows Ouistreham, on the eastern side of Sword Beach. The water splashes result from the Germans trying to shoot down the reconnaissance aircraft!

**3** In 1942 10 million holiday photographs and postcards like this one (showing Courseulles, on what would become Juno Beach) were collected through a public appeal across the UK. These innocent pre-war scenes could reveal useful details about the gradient of a beach, the layout of beach exits, and so on.

The 'Funnies' – the specialist tanks of British 79th Armoured Division – played a valuable part on D-Day. This flail tank (seen in France after D-Day) has chains on a drum attached to the front of the vehicle that, when spun, strike the ground, harmlessly setting off any mines in its path. (Canadian Military photograph)

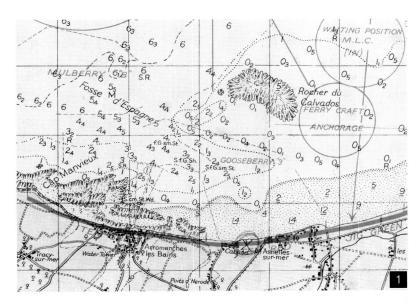

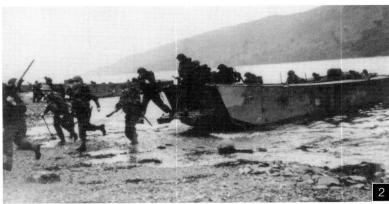

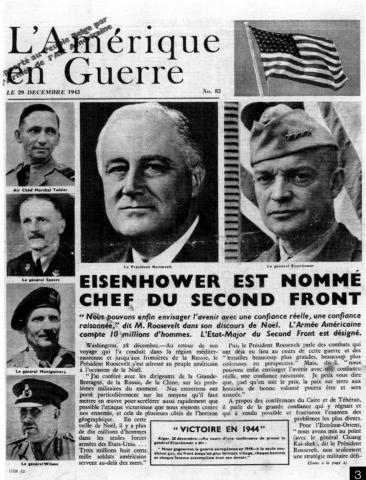

**1** Only limited information about Normandy's terrain was available from before the war. This wartime chart records the depth soundings of the water off Arromanches, future site of the British Mulberry Harbour. These soundings were secretly taken at night by reconnaissance personnel of COPPS (Combined Operations Pilotage Parties).

**2** British soldiers dash from their landing craft during a training exercise. Troops who landed on D-Day had received extensive training in amphibious landings, beginning on a small scale and culminating in major practice landings.

**3** This issue of an American propaganda leaflet, dropped by air over Belgium in December 1943, announces the appointment of Eisenhower as Supreme Allied Commander for D-Day. It was important that the people of occupied countries felt that the Allies would one day land in Western Europe.

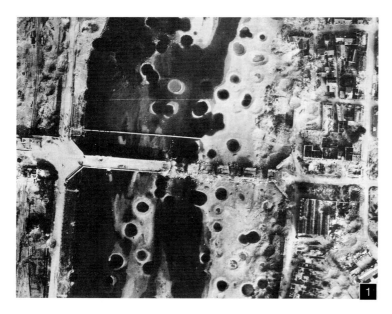

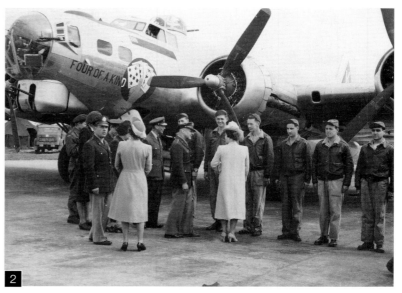

**1** A vertical aerial photograph showing the road bridge over the River Loire at Saumur. Allied bombing has cut this route, which could otherwise have been used by German reinforcements approaching Normandy from the south. Adjacent civilian buildings have clearly also been hit in the bombing.

**2** King George VI, Queen Elizabeth and Princess Elizabeth meet the crew of an American B-17 Flying Fortress bomber of 379th Bombardment Group (Heavy) during a visit to Kimbolton Airfield, 6 July 1944. The US, British and Commonwealth air forces played vital roles in preparing for D-Day.

### What does the 'D' in D-Day stand for?

The 'D' does not stand for a particular word (although it is sometimes suggested it means 'Day', 'Deliverance', 'Doom', 'Disembarkation', etc.). 'D-Day' is an expression for the day on which a military operation begins, and 'H-Hour' refers to the time it starts. The term 'D-Day' has been used in many military operations, but is now most widely used to refer to the first day of the Normandy landings on 6 June 1944.

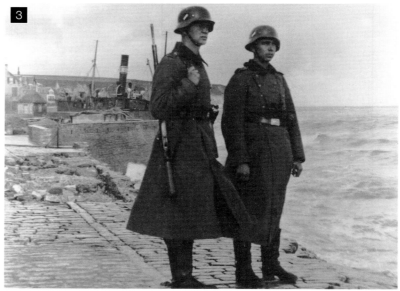

**3** Two German soldiers patrol the seafront at Arromanches. By the time of D-Day the German forces had spent years awaiting an Allied attack. (Collection Musée du Debarquement, Arromanches)

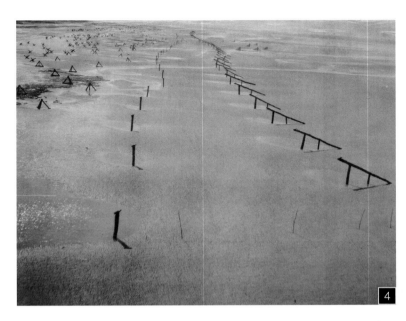

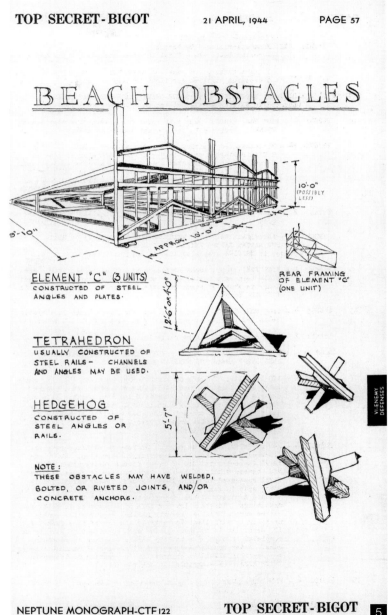

**4** A very low-level photograph showing German beach obstacles, taken by an American aircraft on 19 May 1944. The obstacles include mine-tipped logs and posts (foreground, right and centre), tetrahedrons and X-shaped 'hedgehogs'. All were designed to capsize or blow up landing craft, or rip a hole in their undersides.

**5** A page from the US naval orders for Operation Neptune, giving information about German beach obstacles that would likely be encountered. The huge 'Element C', also known as Belgian Gates, would block a vessel's path. Other obstacles were designed to sink craft.

### Why was the expression 'D-Day' used?

When a military operation is being planned its exact start date is not always known. The term 'D-Day' is used instead. This allows the date to be changed – as happened with the Normandy landings – without having to revise every reference to the date in the troops' orders, and also helps to preserve secrecy.

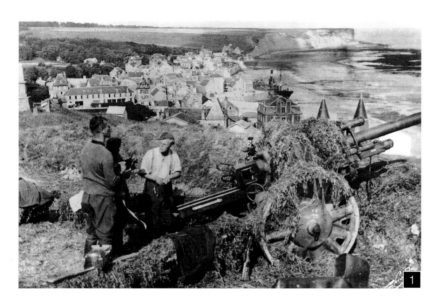

**1** A German field gun on the cliffs overlooking Arromanches. Compared to certain gun batteries that were sited in concrete bunkers, such an unprotected position would be relatively easy to deal with. On D-Day many Allied warships (mainly cruisers and destroyers) were assigned to shell enemy positions such as this. (Collection Musée du Debarquement, Arromanches)

**2** A machine gun bunker on Sword Beach, located between Riva Bella and Lion-sur-Mer. It is being disguised as a civilian house. Photograph taken after D-Day by R.F. Stubbs, while serving in a Beach Group.

**3** Underground newspapers distributed in German-occupied Caen by the local French Resistance group, including André Heintz. At the bottom is a ticket that was sold to help local students who were in hiding to avoid being sent to Germany as forced labourers.

**4** Lorries carry rubble from bomb-damaged buildings onto a ferry at Portsmouth Harbour, for use in building embarkation hards (ramps on beaches to enable vehicles to load onto landing craft for D-Day). The liberation of Europe was literally launched over the ruins of Britain's towns and cities.

**5** A military policeman checks a civilian cyclist's identity papers on a Southsea street, 17 August 1943. From this day onwards, in the lead-up to D-Day, the Southsea seafront area of Portsmouth was off-limits to all except those who lived or worked there. (Courtesy of *The News*, Portsmouth)

**6** American landing craft approach the beach at Slapton Sands, Devon, during a practice landing before D-Day. Here and at other sites in the UK thousands of local people were moved from their homes over a period of several years so that exercises involving live weaponry could be carried out. (US Navy photograph)

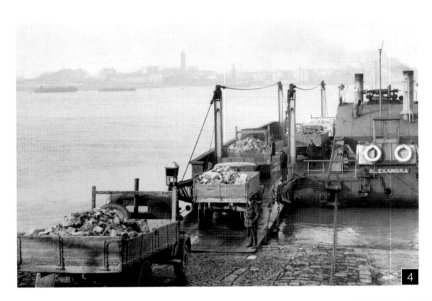

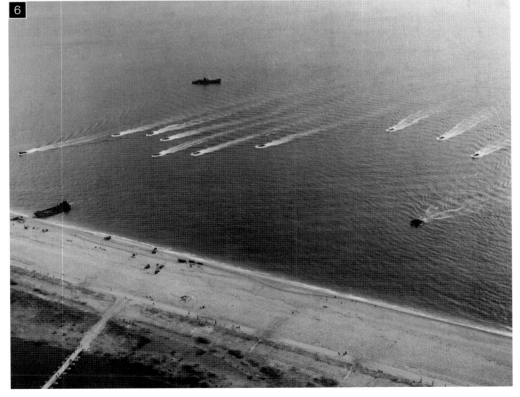

### Tea or coffee, sir?

The Supreme Allied Commander for D-Day, US General Dwight Eisenhower, was determined that the different nationalities at the Allied headquarters should get along. According to his grandson David, Eisenhower implemented a system of American-style coffee breaks in the morning and British-style tea breaks in the afternoon, as one way of promoting understanding between the two countries.

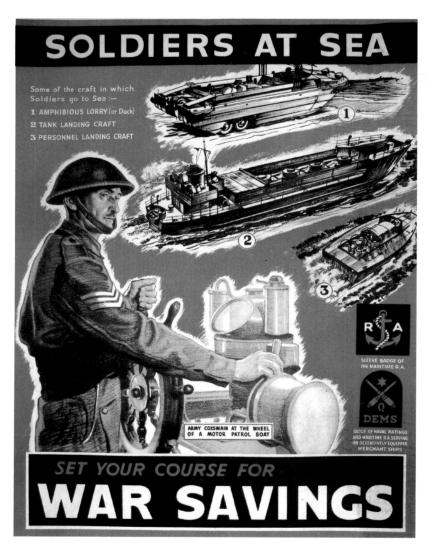

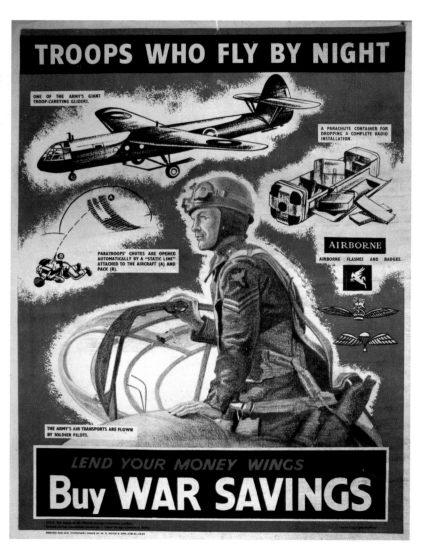

A British government poster urging citizens to invest in the War Savings scheme, as a way of financing the war effort. The poster shows a DUKW amphibious vehicle and two types of landing craft, as used by the British Army in amphibious operations.

Another War Savings scheme poster, this time illustrating the equipment of the British airborne troops. At the top is an Airspeed Horsa glider, which could carry up to thirty troops.

# two

# 'EMBARKING ON THE GREAT CRUSADE': D-DAY IS LAUNCHED

As D-Day drew near, Allied intelligence officers anxiously watched for changes in German deployments in Normandy, or any other any sign that the enemy might have got wind of the imminent invasion. Secrecy was vital to the success of the landings. In one sense the forthcoming landings were no secret: the Germans were well aware that an invasion was coming. What they did not know was when or where it would take place. Aerial reconnaissance – which the Allies made such use of prior to landing in Normandy – was virtually impossible for the Germans due to the inferiority of their air forces. In the first six months of 1944 only thirty-two German reconnaissance flights were made over the UK in daylight: Allied air defences were simply too strong for the Germans to gain much information this way.

The use of spies seemed to offer more chance of success. The Germans were proud of their network of agents throughout the UK, many of whom had been in place for years. In fact, none were genuine. All German spies sent to the UK had been captured, and some had been 'turned' by the Allies to become double-agents, feeding misinformation back to the enemy.

The most famous double-agent was 'Garbo' (real name Juan Pujol Garcia). He was a Spanish political idealist who strongly opposed the Nazi regime. Employed by the Germans as a secret agent, he then offered to become a British double-agent. From a house in North London he sent messages by radio and letters to his German handlers in Madrid. By 1944 he had been in operation for over two years, and the Germans believed he had twenty-four sub-agents who were collecting information for him in different parts of the UK. This enabled him to give German intelligence misleading information about Allied troop movements before D-Day.

This was just one part of the overall Allied deception plan, code named Bodyguard. Part of this plan, giving the Germans the impression that the Allies would land in the Pas de Calais (northern France), was code named Fortitude South. For every bombing raid, reconnaissance flight or

supply drop to the Resistance in Normandy, two or three were made in northern France to avoid drawing attention to the Allies' intended landing site. All radio signal traffic from 21st Army Group (the ground forces for D-Day) was sent by land-line to Kent, from where it was broadcast, giving the impression that the main Allied troop concentrations were in the far south-east.

Garbo's messages and these other measures convinced the Germans of the existence of the fictitious First US Army Group, under Lieutenant General George Patton, which they thought was assembling in south-eastern England prior to invading the Pas de Calais. They believed that the Allies had twice as many soldiers as they did in reality. Dummy landing craft, tanks, camps and supply depots were also used in the deception plans, to fool enemy spies and reconnaissance aircraft.

Another invaluable tool that the Allies possessed was what was known as Ultra. This referred to intelligence gathered from intercepted German radio messages, which the Germans had encoded for secrecy using the Enigma machine. The Germans had every confidence that their messages were so thoroughly encrypted that they could not be understood by the Allies. Different parts of the German armed forces used different codes, and the codes were changed at intervals. With each change, the Allied code-breakers at Bletchley Park had to try and break the code as fast as possible, which could take a long time. In January 1944 communications between Berlin and the Commander-in-Chief West, Field Marshal von Rundstedt, began to be encoded using the Enigma machine. This particular code was broken by the Allies from the end of March, enabling them to 'listen in' to the messages of the top German commander in France.

Even Ultra intelligence had its limitations, and it did not win any victories by itself. For fear of revealing its source, detailed intelligence gained in this way could only be given to the most senior Allied commanders, who could

not share it with their subordinates. Ultra was sometimes incomplete and, following each change of code, was not always available. In fact, due to a change of codes the Allies could not read the messages of the German army for the first forty-eight hours of the landings, and could not consistently read the new codes until 17 June.

The story of Ultra could almost give the impression that the Allies knew everything about the German forces in Normandy, yet this was certainly not the case. Ultra only provided certain information. On D-Day the main German armoured forces in France had in reality around 1,420 first-rate tanks and assault guns (assault guns were similar to a tank, but generally had

**Monty's double**

As part of the Allied deception plan, British actor M.E. Clifton James – who bore a great resemblance to General Sir Bernard Montgomery – went to the Mediterranean 'in character', playing 'Monty'. Allied intelligence hoped that this would suggest to the Germans that D-Day would take place in that region, not in northern France. Unfortunately, whilst at Algiers, James got drunk (Montgomery was teetotal) and the deception had to be ended.

Dummy landing craft at anchor in Dover Harbour, 1944. The Allied deception plans included 255 fake landing craft like these, designed to suggest that an invasion army (which in reality did not exist) was gathering in south-east England.

the gun mounted in the hull, not in a turret). Allied estimates of this figure varied wildly between different intelligence organisations, from 1,120 to 3,000.

As D-Day approached, reconnaissance flights over Normandy had to be decreased, lest they hint at the planned landing area. During the fifty days leading up to D-Day, only seven out of 735 Allied photographic reconnaissance flights in north-west France flew over the landing beaches. From D-Day onwards 380 such missions were flown every day, which indicates how many would ideally have been flown before 6 June but for the danger of focusing the Germans' suspicions on that region.

## Where did the expression 'Bigot' come from?

D-Day was so secret that the Allies created a new security classification, known as 'Bigot', which was even higher than Top Secret. This referred to anything such as documents or maps that could reveal the location or date of D-Day, and also to anyone with that level of security clearance. At the time of the Allies' North Africa landings in November 1942, the papers of officers going to the Allied headquarters were marked 'To Gib', standing for 'To Gibraltar'. For D-Day, the letters of 'To Gib' were reversed to derive the name for this very highest security level.

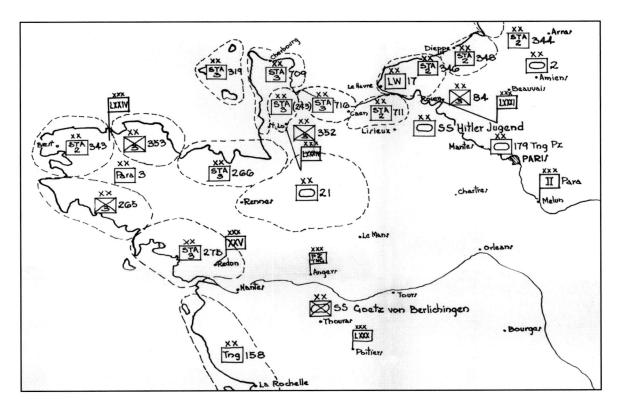

Detail of a map from US naval orders for D-Day showing the location of German divisions in France, as known in mid-April 1944. Static divisions (marked 'STA') guard the coast, while tank units (marked with an oval inside a rectangle) are further back. Several had moved by the time of D-Day.

The Allied plan for D-Day was completed by the end of April 1944, and was based on the knowledge and intelligence then available. The complexity of the plan meant that as D-Day drew near it would be increasingly difficult to make any changes in response to new discoveries about the German defences. An alteration in one aspect of the plan could have had complex knock-on effects in many other areas. In late May Allied intelligence learned that German forces on the Cherbourg Peninsula were being reinforced. This led to one of the few last-minute changes in the D-Day plans. It had originally been intended that the US 82nd Airborne Division would seize key points in the west of the peninsula. With the knowledge of strengthened defences in this area, the division's drop zones were moved further east, closer to Utah Beach and the drop zones of 101st Airborne Division.

The process of moving the huge numbers of Allied troops gathered in the UK over to France was complicated. On D-Day itself 132,000 men were transported to Normandy by sea, and a further 24,000 airborne troops landed from the air, by glider or parachute. After D-Day troops had to continue being landed at a high rate, to match or exceed the rate at which the Germans could bring troops to Normandy by land.

All along the south coast of England a large number of temporary camps had been specially constructed for holding troops prior to D-Day. Generally they were concealed in woods at some distance from towns and cities, in an attempt to hide them from enemy aircraft and spies. However, local people were generally well aware of their existence!

The American assault forces were gathered mainly in south-west England as they would be landing on the western side of the beachhead. The US 29th Division was in Cornwall, US 4th Division was mainly in the Dartmouth-Torquay area and US 1st Division around Weymouth. The American follow-up divisions that would land soon after the assault troops were held on the west coast, largely in South Wales. On the south coast of England the port of Southampton formed the dividing line between the US forces to the west and the Anglo-Canadian troops to the east. The men of British 3rd and 50th Divisions, and 3rd Canadian Division, embarked from Southampton, Portsmouth and other nearby ports and harbours (some as far east as Newhaven). British follow-up forces gathered on the east coast, such as near Tilbury and Felixstowe.

Before embarkation, there was a complex system across the UK known as Movement Control which ensured that the right troops were in the right place at the right time. It had to keep track of 1 million men and 200,000 vehicles moving to around twenty embarkation points. Much of the embarkation system was actually governed by the process of waterproofing the vehicles, which was done so that they could land in several feet of water. This was a major task – it took 286 man-hours to waterproof a tank, for example.

The area within 200 miles of the embarkation points was designated the Concentration Area, where initial waterproofing was done. Once 'concentrated', troops would move to the Marshalling Areas where, within a few miles of their embarkation point, they did the second stage of waterproofing. In each Embarkation Area a series of embarkation sites were designated. Where vehicles were being loaded onto landing craft, beaches had been prepared through the construction of concrete-block hards (loading ramps).

Towards the end of May the assault troops were moved into the marshalling areas, and to prevent any security breaches they were sealed in their camps. In other words, the troops were not permitted to leave, or to have any contact with people outside that camp. Despite the high security there were several cases of troops breaking out of camp in order to see their wives or girlfriends for what might be the last time.

First the officers, and then all troops, were given briefings with maps, photographs and models of the terrain where they would land. At this stage, however, only a select few knew the exact destination for D-Day. Even the French francs and guidebooks that the troops were issued with at this stage were seen by some as a decoy. Most troops were not told that their destination was Normandy until the ships were at sea.

Based on the precise time at which each unit had to land in Normandy, the Movement Control planners had compiled Loading Tables and allocated each landing craft or ship to a particular port or hard. Over 48,000 men and 4,600 vehicles left for D-Day from Southampton, for example, while from the Portsmouth and Gosport area nearly 27,000 men and 4,200 vehicles departed.

In designing this system the planners gave considerable emphasis to the troops' physical condition and morale, both in the camps and during the Channel crossing (although in the event the crossing was far from comfortable for many troops). Cans of self-heating soup and cocoa were developed so troops would be able to have hot food while on board ship.

The naval force gathered for D-Day comprised over 7,000 ships and landing craft: 1,206 naval vessels, 4,127 landing craft of many different types, 423 ancillary craft and 1,260 merchant ships. The fleet was split into the Western Task Force, associated with the American landings on Utah and Omaha beaches, and the Eastern Task Force that would land the British and Canadian forces. The warships included five battleships, two monitors (small ships carrying large guns), twenty cruisers and sixty-five destroyers

that would protect the other vessels from naval attacks and fire their guns at enemy defences on land.

The German naval defences they would face were not particularly strong, although if not guarded against they could still pose a threat to the transport ships and landing craft. The Germans had a small number of U-boats and fast attack or patrol craft. Sea mines were potentially a greater risk to Allied shipping, but the Luftwaffe had refused to work with the German navy to lay mines in the sea around the Isle of Wight where so many of the Allied ships were gathering. The German navy therefore hoped to be able to lay additional mines off the French coast as soon as an approaching invasion fleet was detected, but in the event they did not have enough warning. However, on D-Day alone, existing German minefields caused severe damage to the destroyer HMS *Wrestler* during the crossing of the English Channel, and sank the destroyer USS *Corry* off Utah Beach.

In the air there was a similar imbalance in the opposing forces in favour of the Allies. They had 4,029 aircraft in their tactical air forces in the UK that were directly allocated to operations in Normandy, plus 5,514 other aircraft (such as fighters defending the UK, or strategic bombers) which could assist with the landings. On D-Day for example, 1,136 RAF heavy and medium bombers would attack a range of targets between midnight and 5 a.m., while 1,083 American bombers would bomb coastal areas shortly before the troops landed.

In comparison, on D-Day the Luftwaffe had 570 serviceable aircraft of all types in France and the Low Countries. This figure included only ninety-three anti-shipping aircraft, forty-eight fighter-bombers and 115 of the best types of fighters. A further 964 aircraft were currently tasked with the defence of Germany, many of which would be moved to support the fighting in Normandy, weakening the homeland's defences.

The date on which D-Day could be launched was governed by a precise set of conditions. The Germans assumed that the Allies would land at around high tide, when the assault troops would have the narrowest stretch of beach to cross. Rommel had therefore built large numbers of obstacles close to the high tide mark. In fact the Allies decided to land midway between low and high tide, while the tide was coming in. The idea was that this would reduce the stretch of beach that the troops had to cross compared to low tide, but would still leave many of the obstacles out of the water so that they could hopefully be cleared before the sea covered them.

This state of the tide had to occur not long after first light. The moon on the previous night had to be full or nearly full so that its light could be used by air crews and airborne troops to achieve their aims. On D-Day and for the next two days the wind had to be Force 3 or less (under 12mph) over the land, and Force 4 or less (under 18mph) out at sea. Stronger winds would scatter paratroops around the countryside and many small craft might be swamped at sea. Visibility off the French coast had to be at least three miles so that warships could accurately bombard enemy positions. Clouds that were too low or covered too much of the sky would interfere with the airborne and air forces.

This combination of factors meant that there was a window of three days, 5–7 June, when the landings could take place, provided that the weather was suitable. The first of these days, Monday 5 June, was selected as the provisional date for D-Day. The Allied fleets began to gather and to load troops from 31 May, with some naval forces travelling from as far as Scotland. Due to the size of the Allied landing forces, and particularly the number of vehicles which would take time to load in the most efficient manner, the main loading process would not be complete until 3 June.

This complex process could not easily be paused or put into reverse if a postponement was necessary for whatever reason. The longer the Allied forces were gathered together, waiting to depart, the more likely it was that the Germans would detect the imminent invasion and even guess its destination.

Despite Allied secrecy, the Germans were aware of Allied shipping gathering in the Portsmouth-Southampton area, for example. They had identified Normandy as one of several possible landing sites. With hindsight one can see other clues that might have revealed the secrets of D-Day. For example, a variety of nonsensical phrases were to be read over BBC radio before the landings. These were messages for the French Resistance warning them that D-Day was imminent and that they would soon need to begin various operations in support of it. One of these messages was taken from a poem by Paul Verlaine and was aimed at one particular Resistance group that had been tasked with railway sabotage. The first part of the poem meant that D-Day would take place within one month, and was broadcast on 1 June. The second phrase meant that the landings would take place within forty-eight hours, and was broadcast on 5 June.

German military intelligence had discovered the coded meaning of this particular message, and heard both parts of it on the radio. But there had been other invasion alarms in recent months, and many German commanders simply did not believe that the Allies would announce D-Day on the radio in this way. Although the German Fifteenth Army in the Pas de Calais was put on alert, Seventh Army in Normandy was not. In fact, by June 1944 German intelligence officers in France were receiving twenty-five reports each day

# L'ARC EN CIEL

No. 15

**Apporté au Peuple Belge par l'Aviation des Nations Unies**

LE 9 JUIN 1944

# EN FRANCE, L'AVANCE CONTINUE

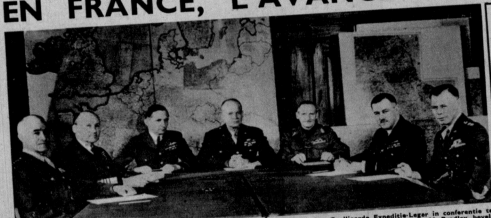

Les chefs des Forces Expéditionnaires Alliées. De gauche à droite : Le général Omar N. Bradley, commandant les armées de terre américaines ; Sir Bertram H. Ramsay, amiral britannique, commandant les forces navales ; Sir Arthur William Tedder, Maréchal-en-chef de l'Air britannique, Commandant Suprême adjoint et le général Dwight D. Eisenhower, Commandant Suprême des Forces Expéditionnaires Alliées ; le général Sir Bernard L. Montgomery, commandant les armées de terre britanniques ; Sir Trafford Leigh-Mallory, Maréchal-en-Chef de l'Air britannique, commandant les forces aériennes ; le général Walter B. Smith, Chef d'Etat-Major.

De leiders van het Geallieerde Expeditie-Leger in conferentie te Londen. Van links naar rechts : Lt.-Gl. Omar N. Bradley, bevelhebber der Amerikaansche landlegers ; Sir Bertram H. Ramsay, Britsch Admiraal, opperbevelhebber der vlootmachten ; Sir Arthur William Tedder, Britsch Hoofd-Luchtmaarschalk, toegevoegd Opperbevelhebber en Generaal Dwight D. Eisenhower, Opperbevelhebber van het Geallieerde Expeditie-leger ; Generaal Sir Bernard L. Montgomery, bevelhebber der Britsche landlegers ; Britsch Hoofd-Luchtmaarschalk Sir Trafford Leigh-Mallory, Bevelhebber der Luchtmachten ; Lt.-Gl. Walter B. Smith, Staf-Overste.

## Pierlot: courage, discipline, solidarité et confiance

M. Pierlot, Premier Ministre, a adressé l'appel ci-dessous à la population belge :

Mes chers compatriotes, l'heure tant attendue par vous est proche. Les opérations préliminaires pour la libération de l'Europe ont commencé. Cet assaut initial est l'annonce

## EISENHOWER: ENSEMBLE NOUS VAINCRONS

Le général Eisenhower, Commandant Suprême des Forces Ex-

## Le Roi George VI adresse un appel aux Britanniques

Le mardi 6 juin, à 9 heures du soir, S.M. George VI, Roi de Grande-Bretagne, a adressé aux Peuples britanniques un message dont

### COMMUNIQUE ALLIE No. I

Le 6 juin, à 9h. 30 du matin le G.Q.G. du général Eisenhower publiait son premier communiqué:

" Sous le commandement du général Eisenhower, des forces navales alliées, appuyées par de puissantes forces aériennes, ont commencé le débarquement des armées alliées ce matin sur la côte nord de la France."

G.Q.G. allié, 8 juin.—A l'aube du 6 juin, les troupes anglo-américaines se lançaient à l'assaut de la forteresse européenne. Ce matin 8 juin, la première ville française était libérée de l'ennemi: les Alliés ont fait leur entrée dans Bayeux, acclamés par une population qui manifestait une joie délirante.

D'autre part nos troupes ont coupé en plusieurs endroits la route de Bayeux à Caen. Les contre-attaques ennemies, tant sur mer que sur terre, ont été repoussées. Les lignes de communications de l'ennemi sont constamment pilonnées sur ses arrières, ainsi que les concentrations de troupes et de matériel.

Le débarquement du 6 juin, " le premier d'une série de débarquements en force sur le continent européen," déclarait le même jour aux Communes M. Churchill, fut précédé du bombardement aérien le plus formidable jamais entrepris par l'aviation alliée.

An Allied propaganda leaflet dropped on the Netherlands after D-Day. The photograph shows the Allied commanders at Norfolk House in London, February 1944. Just before D-Day the same men met regularly at Southwick House, just north of Portsmouth, to make the decision to launch D-Day.

from a variety of sources warning that the invasion would take place on a specific date or at a specific place, so it was difficult to identify genuine clues amongst all the false leads.

After years of planning, reconnaissance and debate, the armies and fleets had gathered and were waiting for the order to depart. The decision on whether to launch the invasion fell to the Allied commanders, and ultimately to Eisenhower as Supreme Allied Commander. In true British fashion so much came to depend on the weather.

In the days leading up to D-Day, the commanders met at Southwick House, a stately home a few miles north of Portsmouth. Since 26 April 1944 the house had been the headquarters of Admiral Ramsay, the Allied Naval Commander for D-Day. Closer to the date of the landings Eisenhower and Montgomery (and their respective staffs) moved to nearby sites.

On the morning of 3 June, two days before the intended date for the landings, the commanders were briefed by the chief Allied weather forecaster, Group Captain James Stagg. The forecast was for unsuitable conditions, with low cloud, strong winds and rough seas, and D-Day was provisionally postponed; the postponement was confirmed in the early hours of 4 June. Those naval forces that had the furthest distances to travel were already at sea. Orders were sent out to recall them, but one convoy of over 100 vessels bound for Utah Beach was not recalled until around thirty miles south of the Isle of Wight, risking the loss of surprise for the entire landings.

A key meeting of the Allied commanders took place at 9 p.m. on 4 June. Stagg predicted a thirty-six-hour improvement in the weather. Although conditions would not be perfect, the wind and rough seas seemed likely to ease up enough for the operation to work. Only minutes remained before the first ships would have to depart. In the face of doubts from Tedder and Leigh-Mallory (from their perspectives as airmen), Eisenhower took the decision to launch the operation.

After this long process of decision-making, when it came to 6 June itself the Allied commanders had very little to do – apart from waiting on news from the beaches.

Fortunately Eisenhower's decision proved to be correct. However, there are several ways in which events could have taken a different turn. First, Eisenhower might have ignored the forecast for 5 June (which was after all a prediction, not a certainty) and decided that D-Day had to be launched whatever the weather. This was what Montgomery recommended; no doubt keen to get to grips with the enemy and mindful of the increased chance of discovery by the enemy as each day went by.

On the other hand the Allied forecast for 6 June might have been too optimistic. In the event the indifferent weather did cause problems for Allied troops on D-Day, scattering paratroopers and causing many problems on the beaches. Higher winds, lower clouds, rougher seas or decreased visibility could have meant launching the landings with less effective air support, few concentrated airborne forces, and less accurate naval gunfire support.

Finally, Eisenhower might have decided that the weather forecast for 6 June was too uncertain, and have decided on a further delay, as the air commanders suggested. The next period when the conditions might be suitable was 18-20 June. In the event, on 19-21 June there was a major storm which caused considerable losses to Allied naval forces, and which would surely have prevented the initial landings from taking place. Had the landings been delayed until July, the Germans might have discovered that the Allies intended to land in Normandy, and in any case would have had another month to strengthen the defences there and reinforce the garrison.

In fact the Allies thought it likely that the Germans would have from twelve to twenty-four hours warning of the impending invasion. Even this small degree of warning could have given the Germans time to start moving tank reserves forward towards the beaches, and to position night fighter aircraft to attack the transport planes carrying the Allied airborne troops. The size of the Allied forces and the length of time they would take to cross the English Channel made detection at the last minute quite possible, even by a single reconnaissance aircraft or patrol boat. Allied minesweepers arrived off Utah and Omaha beaches at 7.40 p.m. on 5 June, and were close enough to see the French coast. The minesweepers were clearing safe channels along

### Did the secret of D-Day get out?

A briefcase containing a complete set of D-Day plans was left behind on a train and was found at Exeter station by a railway worker. Another set of secret papers was left in a London taxi, but the driver returned them. A US Army sergeant at Eisenhower's HQ accidentally sent secret documents to his sister in the USA (he was tired and wrote the wrong address on the packet). In all these cases, the secret of D-Day was preserved.

which the remainder of the Allied shipping could proceed. Due to the size of the area to be cleared they had no choice but to begin their work so early. An hour later some were close enough to make out buildings on the shore.

This was another opportunity for the Germans to gain a last minute warning of the landings. Observers on the coast did report activity out at sea, and a small group of E-boats (fast attack boats) were ordered out to sea from Le Havre. At around 5.30 a.m. three E-boats attacked the shipping heading for Sword Beach, sank the Norwegian destroyer *Svenner* and narrowly missed several other ships with their torpedoes.

The Allies had stacked the odds in their favour against detection by destroying seventy-six of the ninety-two German coastal radar stations, and jamming the remainder. The weather also helped. On the morning of 5 June the chief German meteorologist predicted winds of Force 6-7 (25-38mph) off the coasts of Normandy and the Pas de Calais. The Germans believed that if the wind strength was Force 4 or over, the sea would be too rough for amphibious landings. They also predicted low cloud, which would have ruled out aerial or airborne operations. The weather in the English Channel came mainly from the west, but Allied dominance of the Atlantic meant the Germans did not have ships or aircraft there to collect adequate weather data. So much on D-Day depended on a small number of Allied ships and aircraft out in the Atlantic gathering data to enable accurate weather predictions to be made.

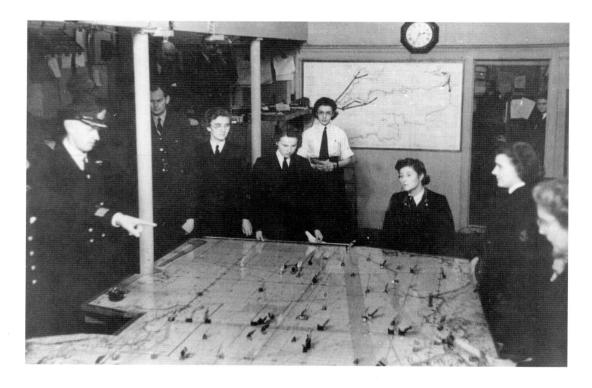

Less famous than the nearby Southwick House, the underground headquarters at Fort Southwick played an important role in the co-ordination of D-Day. Seen here is the map on which naval movements in the English Channel were plotted before being relayed to Southwick House and other headquarters.

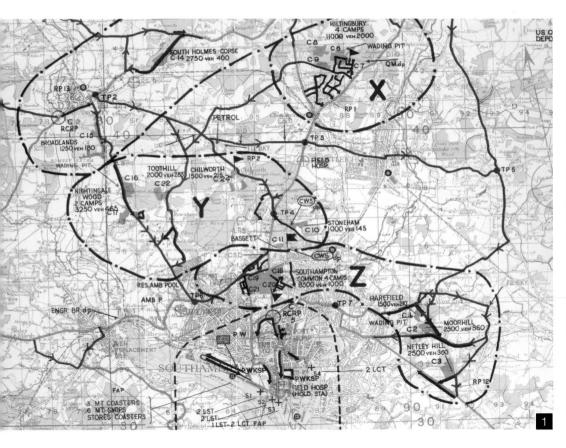

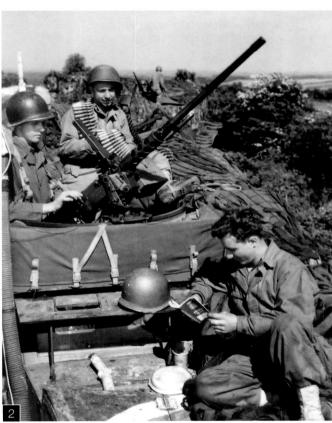

**1** Map showing some of the camps of Marshalling Area C, around Southampton, that were used by troops waiting for D-Day. By 9 August 1944, 571,000 personnel (mostly British and American) and 109,000 vehicles had loaded at Southampton onto ships bound for Normandy.

**2** US soldiers in an M3A1 halftrack wait to embark for D-Day. One is reading a guide to France, specially prepared for the invasion. Due to the numbers involved vehicles were often parked along roadsides while the troops waited. (Conseil Régional de Basse-Normandie / US National Archives)

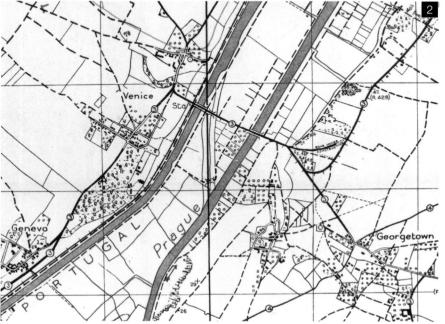

### The D-Day crosswords

Over four days between 2 May and 1 June 1944 the *Daily Telegraph* crossword featured the D-Day codewords: 'Utah', 'Omaha', 'Overlord', 'Mulberry' and 'Neptune'. Allied intelligence feared a security leak, and questioned the man who set the crosswords, school headmaster Leonard Dawe. Various theories have been suggested, but it appears to have been just a bizarre coincidence.

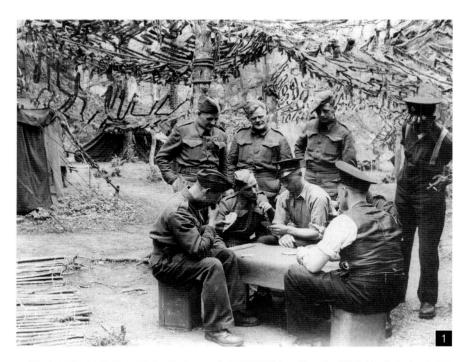

1   British soldiers play cards with firemen (some of whom also went over to Normandy after D-Day) in one of the marshalling area camps. This shows the camps' temporary nature (mainly tents) and how they were well camouflaged and often hidden in woods.

2   So-called 'bogus' maps like this one were used to brief troops before D-Day. To preserve secrecy all the details of the maps were correct except for the place names. 'Venice' is in fact Bénouville, and the bridge across 'Portugal' is really the famous Pegasus Bridge over the Caen Canal.

3   A US Navy officer briefs crewmembers of the battleship USS *Nevada* several days before D-Day. *Nevada* was allocated to the operation in April when it was felt that more naval firepower would be needed to support the troops ashore. (US Navy photograph)

4   British Army and Royal Marines personnel wait in a Southampton street before embarking for D-Day. On the right is a Universal Carrier belonging to 50th Division which has been fitted with high metal sides to enable it to wade through deep water. Taken by Oliver H. Perks of 90th Field Regiment, Royal Artillery.

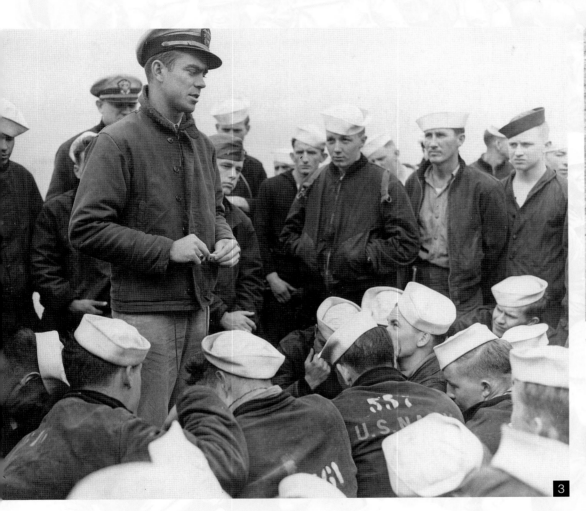

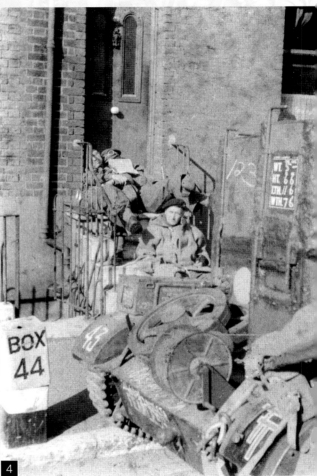

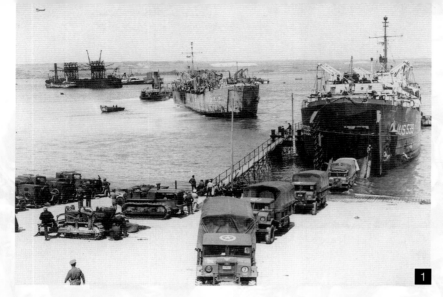

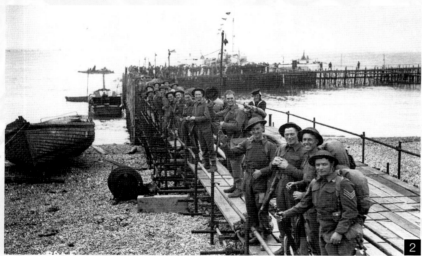

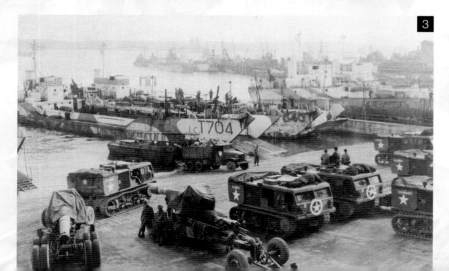

**1** British Army lorries load onto an American Landing Ship, Tank (LST) at Hardway in Gosport, Hampshire. They are reversing onto the ship so that on reaching Normandy they will be able to drive out forwards. Portsmouth Harbour is in the background.

**2** Men of the Royal Engineers use a temporary pier on the Southsea seafront to load onto a Landing Craft, Infantry (LCI). This pier was sited alongside South Parade Pier, which in peacetime was frequented by holidaymakers. (Courtesy of *The News*, Portsmouth)

**3** American vehicles and 155mm 'Long Tom' guns are loaded onto several LCTs (Landing Craft, Tank) at Weymouth. This photograph illustrates the complexity of the embarkation process. Troops, vehicles and equipment had to be loaded onto the right landing craft, in the right order. (Courtesy of Royal Naval Museum, Portsmouth)

**Opposite:** American soldiers (mainly from 1st Infantry Division) bound for Omaha Beach wait on a landing craft at Weymouth before D-Day. The African-American soldier on the right was probably a member of a barrage balloon or engineer unit. (Conseil Régional de Basse-Normandie / US National Archives)

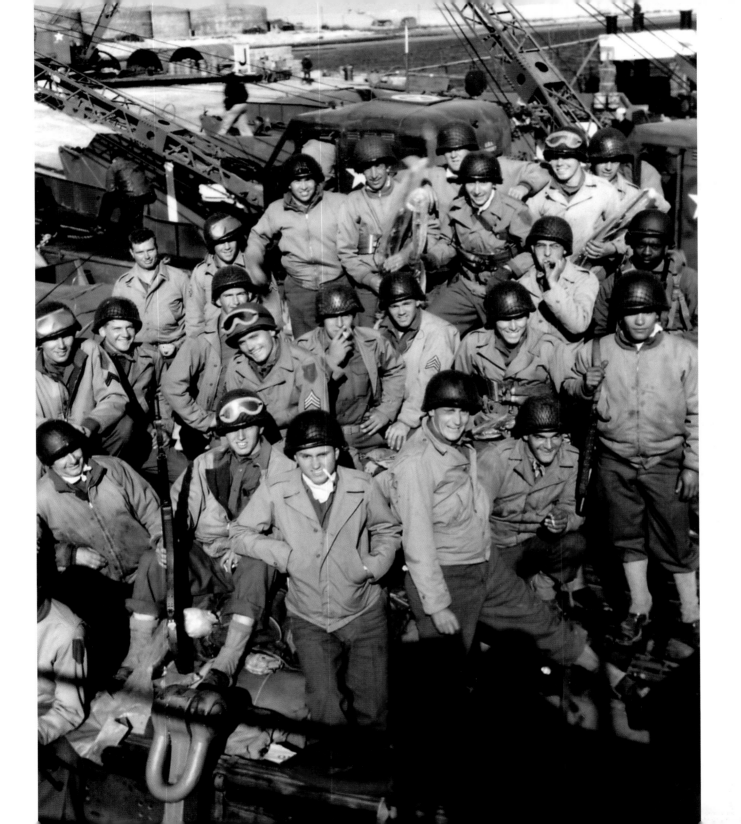

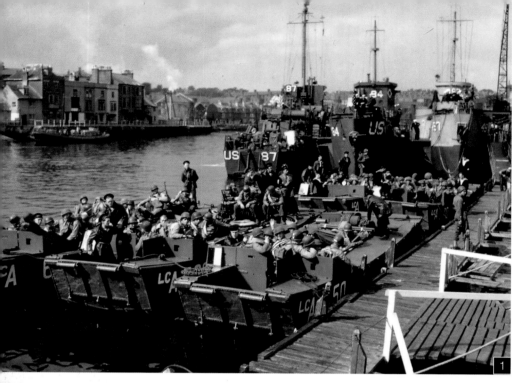

**1** US troops embark for D-Day at Weymouth. In the foreground are Rangers in British-manned LCAs (Landing Craft, Assault). The Rangers landed at Pointe du Hoc and Omaha Beach on D-Day. (Conseil Régional de Basse-Normandie / US National Archives)

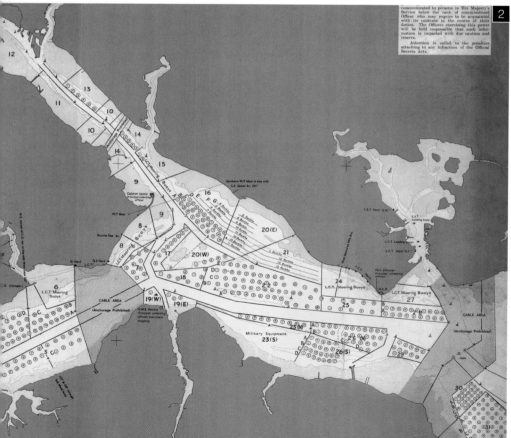

**2** Detail from a chart showing mooring sites in the Solent (between the Isle of Wight and mainland UK). There were hundreds of berths for ships and large landing craft in this area alone. (Courtesy of David Maber)

**3** Ground crew of No.411 Squadron, Royal Canadian Air Force, paint 'invasion stripes' on a Spitfire IXe fighter at RAF Tangmere on 5 June. The stripes were a recognition marking, to prevent Allied aircraft being shot at by their own side as had happened during the 1943 Sicily landings. (Courtesy of Tangmere Aviation Museum)

**4** Allied aircraft flew 14,674 missions on D-Day. This wartime map indicates some of their roles. The red arc shows the area within which enemy airfields would be attacked. The dots are railway targets that were to be attacked by Allied bombers, to delay German reinforcements moving to Normandy from elsewhere in France. Other aircraft provided close protection to the main fleets, or operated on either flank of the landings to guard against enemy U-boats (submarines) and warships. The areas of land marked out in grey are those considered most suitable for the development of airfields after the ground troops had advanced.

**5** Men of US 82nd Airborne Division check each other's equipment as they prepare to depart for D-Day from RAF Saltby in Lincolnshire. Their aircraft would take off in the late evening of 5 June, and they landed in Normandy early on D-Day. (Conseil Régional de Basse-Normandie / US National Archives)

**6** Preparations are made at RAF Tarrant Rushton in Hampshire for the reinforcement of the British 6th Airborne Division. On the runway are mainly Hamilcar heavy lift gliders, with Halifax tug aircraft at the sides. The photograph was taken on the afternoon of D-Day, by which time many gliders had already landed in Normandy.

## Finger trouble

On 3 June a teletype machine operator at the Associated Press (AP) – an American news-gathering agency – was practising sending a message about the Allied landings on continental Europe, which were expected in the near future. Her machine was accidentally connected up so that the practice message was broadcast to the media all over North and South America, and to other countries, as if it was real! A correction was issued five minutes later by AP.

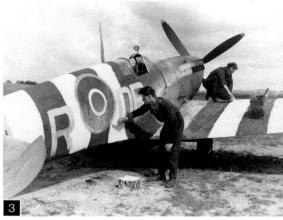

3

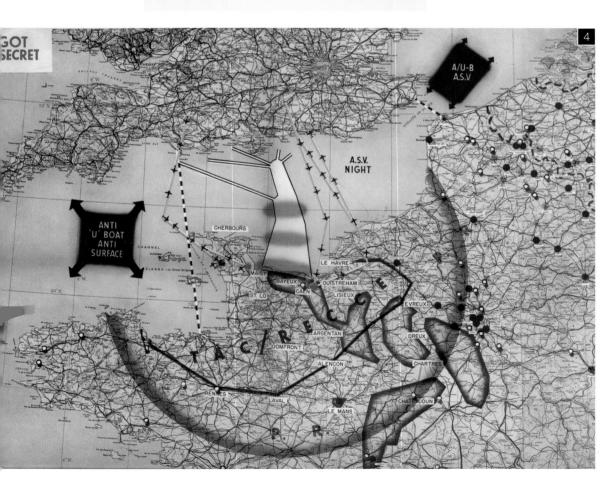

4

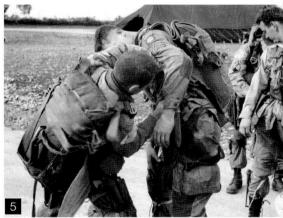

5

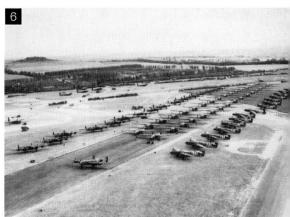

6

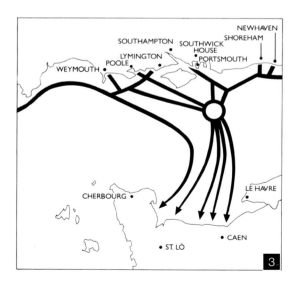

**1** Pages from the log book of Flight Lieutenant Frank Thomas of No.207 Squadron RAF, the navigator of a Mosquito fighter-bomber aircraft. On the nights surrounding 6 June his aircraft patrolled over Normandy, attacking a variety of enemy targets.

**2** A slip of paper bearing an inspirational message from the Supreme Allied Commander, General Dwight Eisenhower, was given to troops landing on D-Day. It began: 'Soldiers, sailors and airmen of the Allied Expeditionary Forces! You are about to embark on the Great Crusade…'

**3** Map showing the routes taken by Allied convoys crossing the English Channel for D-Day. The assembly area to the south-east of the Isle of Wight, marked here with a circle, was known as Piccadilly Circus.

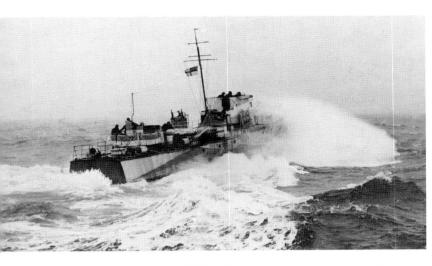

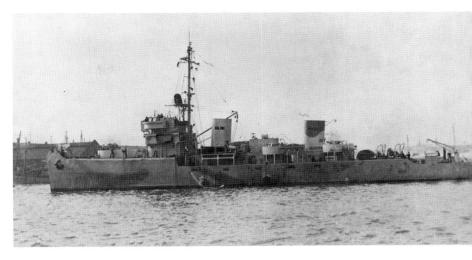

Many Motor Gun Boats like MGB 321, seen here, and other small vessels such as Motor Torpedo Boats (MTBs), took part in D-Day. These coastal craft patrolled the flanks of the invasion fleet as the first line of defence against German naval attacks.

The Catherine Class minesweeper HMS *Gazelle* was part of 40th Minesweeping Flotilla and swept in advance of a convoy heading to Sword Beach. During Operation Neptune over 300 craft were allocated to minesweeping, which was vital in order to prevent many vessels being lost to enemy sea mines.

Sixty of these US Coast Guard 83ft cutters were brought over from the USA to serve as rescue boats on D-Day, and they saved 1,438 men from the sea. Vessels carrying assault troops were forbidden from stopping to pick up men in the water, as this could delay the landings.

The cruiser HMS *Enterprise* was one of many warships tasked with bombarding enemy positions with their guns on D-Day – in her case, at Utah Beach. The majority of the ships at D-Day were British, and many of these served off the American as well as British beaches.

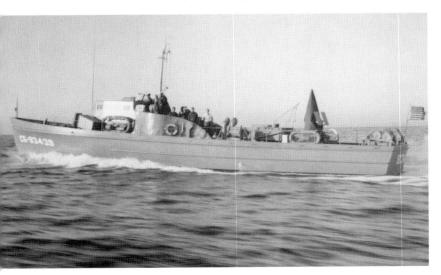

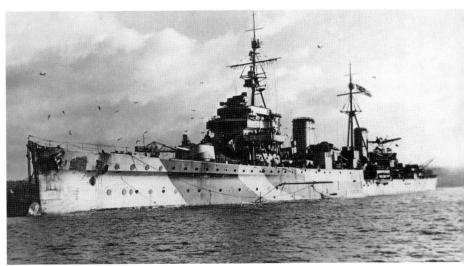

**1** The LCT (Landing Craft, Tank) was one of the key vessels on D-Day. Able to land vehicles on a shallow beach, they were also a smaller target than the bigger transports. This photograph was taken by Lieutenant P.W.D. Winkley RNVR of LCT 979.

**2** USS *Barnett* (APA-5) took part in amphibious landings at Guadalcanal and Okinawa in the Pacific, Sicily, Salerno and the south of France – as well as at Normandy. On D-Day she carried troops of 4th Infantry Division to Utah Beach. LCVPs (Landing Craft, Vehicle and Personnel) can be seen around her. (US Navy photograph)

**3** Many British ships at D-Day were manned by the Merchant Navy, and in total 1,260 merchant ships from many nations took part. This is from the cover of *Our Merchant Ships*, the magazine of the Merchant Navy Comforts Service, which provided merchant seamen with additional clothing, games etc.

### Did Churchill want to take part in D-Day?

British Prime Minister Winston Churchill (then aged sixty-nine) insisted on going with the Allied invasion fleet on D-Day. This would have been too great a risk for a national leader, and could have led to Churchill being out of contact with the rest of the government at a critical moment. He was only dissuaded from going by King George VI, who pointed out that he too wanted to accompany the troops but felt he should not.

# D-DAY IN STITCHES: THE OVERLORD EMBROIDERY

The unique 272ft-long Overlord Embroidery commemorates the events of D-Day and the Battle of Normandy. It is the longest embroidery of its kind in the world, and since 1984 it has been on display at the D-Day Museum in Portsmouth, on the south coast of England. It is not just the Embroidery's length that justifies its fame. It is visually stunning, and when seen for the first time it often literally has the effect of stopping viewers in their tracks.

The most famous commemoration of warfare through embroidery is of course the Bayeux Tapestry, and the Overlord Embroidery is its modern-day equivalent. The Bayeux Tapestry was produced to mark the Norman invasion of England in 1066, some 900 years before D-Day. Both invasions are rightly remembered today for their significance as turning points in history, and their dramatic impact on the people of Britain and the rest of the world.

The driving force behind the creation of the Overlord Embroidery was Lord Dulverton of Batsford (1915-1992). An officer in the British Army's Lovat Scouts from 1935, during the Second World War he set up a Fieldcraft, Observation and Sniping School. Officers and NCOs (non-commissioned officers) from many of the infantry units that landed on D-Day attended training courses there. After D-Day Lord Dulverton went to Normandy to analyse the training needs of the troops.

In the mid-1960s, prompted by the suggestion of a friend, Bill Tyhurst, Lord Dulverton decided to commemorate Operation Overlord with an embroidery loosely inspired by the Bayeux Tapestry (which it in fact came to exceed in length). The project was financed by Lord Dulverton himself.

The Embroidery has thirty-four panels, each 8ft wide and 3ft in height. Each generally covers a different element of the story, although in some cases several panels are grouped together, for example to show the huge Allied fleet crossing the Channel. The panels cover first the early years of the war, followed by the preparations for D-Day, the Allied landings on 6 June, and the subsequent Battle of Normandy.

Lord Dulverton believed that: 'the theme should be national effort, and the involvement of so many people in so many ways, to produce the huge, complex and finally successful expedition' that was D-Day. It was important to avoid adopting a celebratory or propagandist approach that would glorify war.

Sandra Lawrence was selected as the artist to design the Embroidery. Many of its images were adapted by her from wartime photographs. Often parts of several photographs were combined together in a single panel, along with other design elements to link them together. The identities of many people in these photographs were recorded at the time they were taken, or have subsequently been discovered, and this means that many identified lower-ranking individuals are included in the Embroidery, as well as famous personalities.

For each panel Sandra Lawrence made a pencil sketch, which was then considered by a committee that included Lord Dulverton, historians and senior armed forces officers. It was important to represent as many parts of the story as possible, including: the Merchant Navy, different types of ships and landing craft, X-craft mini-submarines, parachute and glider troops, amphibious DD tanks, the 'Funnies' (specialised British armoured vehicles), nurses and medics, army chaplains, the Mulberry Harbours, PLUTO (Pipeline Under the Ocean), Hawker Typhoons and many other aircraft types, and even the dead cows that were left littering so many Normandy fields after the fighting.

One of the best known panels of the Embroidery shows King George VI, General Eisenhower, General Montgomery, Field Marshal Alan Brooke (the British Chief of the Imperial General Staff) and Winston Churchill visiting the Normandy beaches after D-Day.

Once each design was approved, which was sometimes a process involving several revisions, Sandra Lawrence painted a full-size watercolour. This would

form the template for creating that particular Embroidery panel. The actual making of the Embroidery required the expert skills of the Royal School of Needlework. A team of twenty embroiderers and five apprentices worked on it from 1968 to 1972. The final panel to be made (actually number thirty in the sequence) depicts the ruined city of Caen, and was added in order to represent the sufferings of the French people during the Battle of Normandy. It was completed by a single embroiderer in 1973-74.

The first task in making the Overlord Embroidery was to select materials of the appropriate colour and texture to match Sandra Lawrence's designs. Over fifty different materials were chosen, including silk, net, lace and barathea, as well as wartime fabrics such as parachute silk and the woollen battledress cloth used for British soldiers' uniforms.

The embroidery was done on two layers of backing material which were sewn together. Sandra Lawrence's designs were transferred from tracings of her watercolours. Pieces of fabric that would form the larger areas of colour were sewn onto the backing material (appliqué embroidery). Embroidery stitching (in other words, stitching alone) was used for the finer details such as faces or military badges. In comparison, the whole Bayeux Tapestry was made just with stitching, so it is really embroidery, not a tapestry (tapestries are woven on a loom).

The Overlord Embroidery was not specifically designed for the D-Day Museum (this would not be created for another ten years). It toured around North America, and then in 1978 it was put on display at the headquarters of Whitbread's Brewery in London. As the 40th anniversary of D-Day approached, Portsmouth City Council suggested to Lord Dulverton that it would build a new D-Day Museum – centred around the Overlord Embroidery – in that city which had played such a significant part in D-Day itself. On 3 June 1984 the D-Day Museum was opened by Queen Elizabeth, The Queen Mother.

The Overlord Embroidery is known all over the world and is now seen by thousands of people visiting the D-Day Museum each year. As well as being a work of art, it is also a unique tool for telling the story of D-Day. The Embroidery and the Museum both help to ensure that the events of D-Day will be remembered by future generations.

More information and images of the Overlord Embroidery can be found on the D-Day Museum's website: www.ddaymuseum.co.uk.

The Overlord Embroidery on display in the D-Day Museum, Portsmouth, UK. It is 272ft long, and consists of thirty-four panels, each 8ft by 3ft. They tell the story of D-Day from the start of the Second World War to the end of the Battle of Normandy.

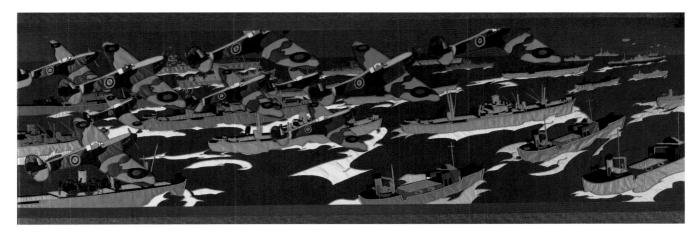

**Panel 12:** The Allied fleet sets sail, supported by RAF Spitfires. In one of the few mistakes in the Embroidery, the black and white identification stripes on these aircraft were omitted.

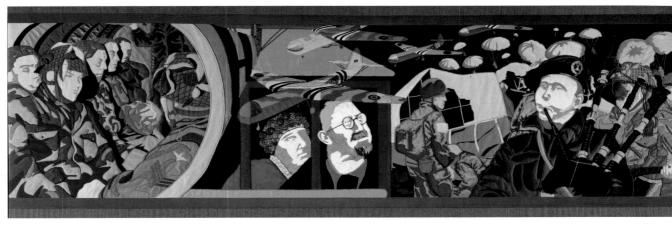

**Panel 17:** British and American airborne troops land, as a French couple peer out of their window and bagpiper Bill Millin (right) leads the Commandos inland off the beaches.

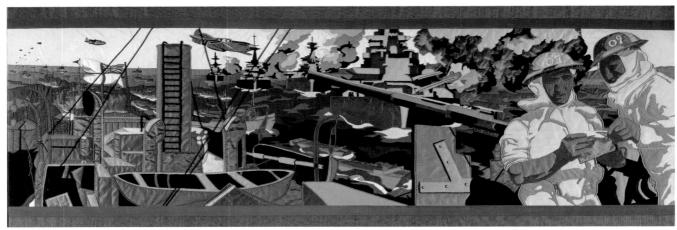

**Panel 20:** Off the coast of Normandy, Allied warships open fire on the German defences before the troops go ashore.

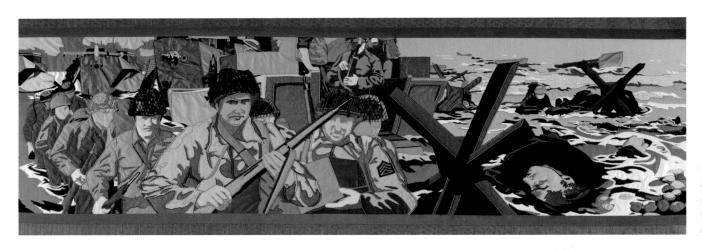

**Panel 22:** One of a pair of Embroidery panels representing the American landings on Utah and Omaha beaches.

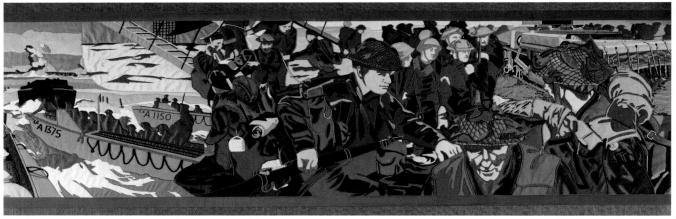

**Panel 24:** One of two panels representing the British and Canadian landings on Gold, Juno and Sword beaches. The photograph that the central scene was based on is on page 79, although in the Embroidery the foreground figure is missing his glasses.

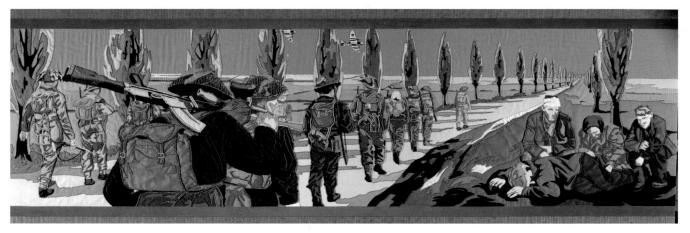

**Panel 34:** At the end of the Battle of Normandy, a platoon of British infantry marches off into the distance to continue the next stage of the war.

# four

# 'WE'RE GOING TO START THE WAR FROM RIGHT HERE': THE AMERICAN LANDINGS

Normandy was in many ways well suited to the Allied amphibious landings. Even so, both the American beaches posed problems for the attackers, although these shortcomings simply had to be overcome so that the overall plan could work (naturally, the *perfect* landing site did not exist!).

The five Allied landing beaches would be weak until they could all be linked together. The landings did not take place along the entire width of coastline, between the outer edges of Utah in the west and Sword in the east. At sixty-one miles in total, this was simply too broad a frontage to land troops everywhere and, indeed, in many places the terrain was completely unsuitable. The attacking forces (both the troops who were landing and the naval and air forces supporting them) had to be concentrated at specific points that were most suited to the landings and that would be particularly important for seizing key objectives. The Americans were allocated to the two westerly landing beaches. This was logical as after D-Day many of their reinforcements would arrive in that direction from across the Atlantic.

The main landing sites on Utah and Omaha were roughly fifteen miles apart in a direct line, or more than twice that by road. In between the two was the estuary of the River Vire, around five miles wide at its mouth. At both beaches there was a natural obstacle that could aid the defenders. At Utah, the area behind the beaches had been flooded with sea water for up to two miles inland. Only a limited number of causeways crossed these inundations. Immediately behind the beach at Omaha there were cliffs (generally referred to as bluffs), which could be climbed by people but which restricted the places at which vehicles could move inland to four ravines, or draws. Even so, the chosen landing site at Omaha was the only suitable gap in the twenty-mile stretch of cliffs between Utah and Gold beaches.

Under the COSSAC plan, developed before the key Allied commanders were appointed, the Allies would have only landed at Omaha, Gold and Juno beaches. Montgomery and Eisenhower insisted that more troops had to be landed on D-Day itself, and that the beachhead had to be wide enough to allow space for reinforcements to arrive. Otherwise the crowded beachhead might be overwhelmed by German counter-attacks before it was properly established. Consequently, Utah and Sword beaches were added on either side. Adding Utah Beach put the port of Cherbourg within easier reach.

Although the airborne were elite troops, they lacked the more powerful weapons and heavy equipment of the troops who would be landed by sea. It was important that they should not be overwhelmed or forced to retreat before they were able to link up with the ground troops. 101st Airborne Division had the task of seizing the causeways to Utah Beach from the opposite end to the amphibious landings, to prevent the Germans from blocking the seaborne troops' advance. 82nd Airborne Division would land further from the beaches in order to seize key bridges and road junctions, including the town of Ste Mère Eglise. Like the mission of British 6th Airborne Division on the east flank of the Allied beaches, holding these locations would both defend against enemy counter-attacks and make it easier for the expansion of the bridgehead when the time was right.

A few minutes after midnight on D-Day, the first Allied forces landed in France. They were the pathfinders for the airborne troops, who would mark the way for their comrades who were due to begin arriving in about an hour. At the same time gliders from British 6th Airborne Division touched down to capture Pegasus and Horsa Bridges to the east of Sword Beach, as will be described in the next chapter. The size of the two US airborne divisions (some 12,000 men each) meant that they had to be landed in several stages throughout the day, with the final airborne forces arriving by glider at 11 p.m.

When the paratroops began to land, many were scattered beyond their intended drop zones. By dawn only around one-sixth of 101st Airborne's 6,600 paratroops had reached their designated rendezvous points. Even more

of 82nd Airborne's soldiers were dispersed. Although this decreased the fighting strength of those units, it did have the unintended consequence of confusing the Germans as to the main targets of the airborne forces.

As well as the real airborne troops, 500 dummy parachutists (crude cloth figures) were dropped across the region to add to the confusion. About half of these, along with some British SAS soldiers, were dropped far to the east of the Allied beachhead. Rifle fire simulators were also dropped, which made sounds suggesting that a fierce battle was being fought.

H–Hour (the time at which the first troops would land from the sea) was 6.30 a.m. on both Utah and Omaha beaches. At Utah two landing sites had been designated, Tare Green and Uncle Red, which were around 1,000 and 1,300 yards in width respectively. At 5.50 a.m. German coastal guns began shelling the fleet. Soon afterwards Allied bombers attacked various coastal targets, after which Allied warships (including rocket-firing landing craft) bombarded the area of the beaches. This massive display of firepower was intended to leave the defenders stunned, demoralised and unwilling or unable to properly resist the first US troops ashore. Although it was not all accurately delivered, this firepower (especially the naval gunfire) destroyed enemy strongpoints along Utah Beach.

The first troops to land at Utah were from 4th Infantry Division, specifically 8th Infantry Regiment, under the overall command of US Seventh Corps. As with all military attacks, when described on the printed page one can get the impression of vast numbers of troops all moving to the offensive, but in fact only a small proportion could land at any one time. The first wave consisted

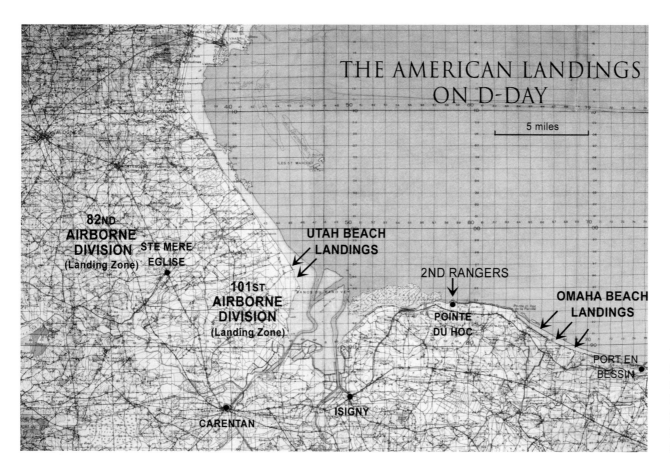

The landings on Utah and Omaha beaches were separated by difficult terrain. Until advancing troops linked the two beachheads together, the American position was not secure.

of twenty landing craft, each carrying a thirty-man assault platoon. In other words, 600 men were to land across 2,300 yards. They were closely followed by thirty-two landing craft bearing – amongst others – combat engineers and eleven naval demolition teams to start clearing paths through the beach obstacles.

The infantry were to be supported by 'DD' amphibious tanks fitted with a canvas screen that enabled them to travel through the water under their own power. They were launched from 3,000 yards out at sea, a shorter distance than originally planned due to the rough seas.

Due to strong currents, poor visibility and navigational craft being sunk, the first waves at Utah came ashore around 2,000 yards further south than intended, at what had been designated Victor Beach. Fortunately this area had fewer defences than the intended landing sites. The commander on the spot, fifty-seven-year-old Brigadier General Theodore Roosevelt (son and cousin respectively of the two US presidents to bear that surname, and who later received the Congressional Medal of Honor for his actions) was faced with the option of redirecting the landings to the designated area: instead he is said to have remarked that 'We're going to start the war from right here', and ordered the following troops to continue landing at the same spot.

While some US troops captured the coastal fortifications, others advanced inland along the nearest causeway in order to link up with 101st Airborne Division. The two following infantry regiments from 4th Division, 22nd and 12th, landed eighty-five minutes apart and four hours after H-Hour respectively. Their role was to advance towards the north-west while the two airborne divisions held ground to the west of Utah, and 8th Infantry Regiment moved south-east to open the way to seizing Carentan, a vital road junction that would connect with Omaha Beach.

By the end of the day the original objectives for Utah and the US airborne had not been fully achieved, but progress was good. Over 21,000 troops, 1,700 vehicles and 1,700 tons of supplies had been landed via Utah Beach. 4th Infantry Division had suffered less than twenty killed and 200 wounded. The ground troops had advanced some four miles inland from the beaches, linking up with 101st Airborne Division. Unbeknown to them, only a mile of undefended land separated them from 82nd Airborne Division. The airborne had suffered heavy losses: 338 men killed, 884 wounded and 1,996 missing.

Although it would create a stronger beachhead once established, the addition of Utah to the Allied plan made the landings more complicated in the short term. As well as linking with the British on Gold in the east, the US forces on Omaha would also need to join with their comrades on Utah to the west. It was therefore decided that two US divisions would land at Omaha: 1st Infantry Division in the east (in overall control for the initial landings) and 29th Infantry Division in the west. The troops of 1st Division were veterans of North Africa and Sicily, and had been brought back to take part in D-Day. 29th Division had not yet experienced combat. Both divisions came under the command of US Fifth Corps.

Omaha Beach was always going to be difficult to capture. Even if the Germans had not built fortifications of concrete and steel, the area's natural defences were a tough proposition. Once off the beach the attackers would have to cross 200 yards of exposed salt marshes before climbing the bluffs which were 100-170ft in height. Added to these were twelve interlocking defence positions with forty-three concrete bunkers, or pillboxes, containing anti-tank guns, at least eighty-five machine guns and many mortars, as well as artillery in support.

Early in 1944 the German garrison at Omaha consisted of a regiment from 716th Static Division, whose frontage stretched all the way to Sword Beach. This was not one of the better German units. In mid-March, however, troops of 352nd Infantry Division were moved to garrison the area of Omaha and Gold beaches. This was a seasoned unit that had fought on the Eastern Front. The presence of troops from this division at Omaha was not, as is sometimes suggested, a coincidence based on their participation in an anti-invasion exercise.

Allied suspicions about the reinforcement of the beaches were raised, but no definite evidence was found to confirm the presence of the 352nd Division. Two days before D-Day, intelligence officers suggested that the division might be there, but it was too late to alter Allied plans. In any case, it is questionable whether the plans could have been significantly changed. The troops landing on Omaha were a strong force and had considerable support from the sea and air. Omaha simply had to be captured.

Many aspects of the plan for the landings at Omaha were similar to those at Utah. However, much of the initial air and naval bombardment directed at the beach defences missed its targets. The ineffective aerial bombardment was one of the consequences of launching D-Day during imperfect weather: the bomber aircraft could not clearly identify their targets through the clouds, and in delaying their attack momentarily for fear of inflicting friendly casualties, their bombs ended up missing the enemy defences completely. The German troops were ready to defend their positions when the Americans came ashore.

Since the Americans landed from 6.30 a.m. onwards (roughly one hour before the first British or Canadian troops), only forty minutes was available

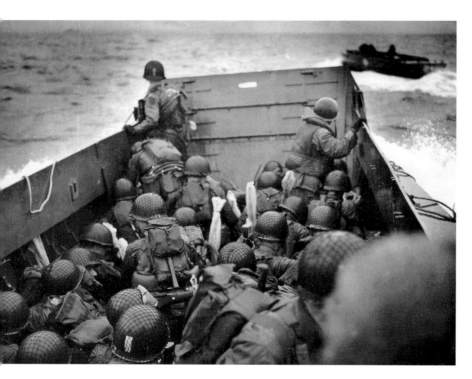

A thirty-man assault team from US 1st Division in an LCVP (Landing Craft, Vehicle and Personnel). They would have been in this small craft for three hours, pitching about in the rough sea. The long white objects are rifles wrapped in plastic bags for protection against salt spray. (Conseil Régional de Basse-Normandie / US National Archives)

in which the warships could deliver their bombardment before the landings, beginning at 5.50 a.m. when there was sufficient natural light. In retrospect, Omaha would have benefited from a longer naval bombardment, even if this had reduced the element of surprise.

The only specialised tanks that the American commanders chose to use on either beach were the amphibious DD tanks. The Americans believed that these tanks, along with armoured bulldozers, could provide sufficient support to the troops. The suggestion before D-Day by one American officer that the first waves of infantry should be in LVTs (Landing Vehicle, Tracked) rather than in landing craft, had been ignored. Also known as Alligators, LVTs were used extensively by the Americans in the Pacific campaign. They were amphibious vehicles with some armour protection and a top speed on land of 18mph, which could have taken troops up onto the beach rather than dropping them at the water's edge like the landing craft.

Sixty DD tanks were to be used at Omaha, but the majority sank before reaching the shore. Twenty-six wheeled artillery pieces, being carried ashore on the backs of DUKW amphibians, also sank before landing. Ten of the smaller landing craft were swamped by rough seas during the eleven-mile journey to the beach, a journey that took around three hours. Strong currents pushed many landing craft into unfamiliar sectors, confusing the overall plan.

## Why do the beaches have names like Dog Red, Fox Green, etc?

The entire Allied beachhead was around sixty-one miles wide. Within that, each beach (Utah, Omaha etc.) was many miles across. For greater precision they were divided up into smaller stretches, each beginning with a different letter of the alphabet, from P to V on Utah, then beginning again with A to F on Omaha, continuing to R at the far east of Sword. These were each again subdivided into either two sectors (Red and Green) or three sectors (Red, White and Green). For example, Dog Beach was around 2,000 yards long, and within that Dog Red was about 500 yards across.

The first troops to land often did so in water that was waist–deep or higher, and those men who did survive often lost many of their weapons and equipment in the process. The troops were met by fire from machine guns, mortars and artillery, and found it impossible to advance up the beach. One of 116th Infantry Regiment's first wave units, 'A' Company, lost 60 per cent of its men in the first fifteen to twenty minutes. The incoming tide advanced at a fast rate, drowning many wounded men.

Successive waves of troops landed behind them, only adding to the confusion and casualties. The engineers were unable to clear enough routes through the beach obstacles, and as the tide came in many landing craft hit these as they neared the land. The scenes at Omaha have been made famous by Robert Capa's photographs taken on that morning (all but ten of Capa's 106 shots from Omaha were accidentally destroyed while the negatives were being developed back in the UK), and later featured in Stephen Spielberg's 1998 film *Saving Private Ryan*.

Gradually holes began to appear in the German defences. Between 9.30 a.m. and 11 a.m. in several places small groups of American troops managed to find ways through the defences towards the inland villages of Vierville, St Laurent and Colleville. The advance was aided by the fire of destroyers that came close in to the shore and used their guns to destroy German strongpoints at almost point-blank range, and also by smoke from fires started in the undergrowth that screened the Americans. Sometimes it was pure luck that troops landed in a position that was not directly in front of an enemy strongpoint. The landings were no longer in crisis, but their outcome was still not certain.

By the end of the day 34,250 troops were ashore at Omaha. They were in scattered pockets over an area approximately five miles wide by one and a half miles deep, rather than in a single, firmly held beachhead. The exact frontline was not clear, which made it harder for Allied warships to fire their guns in support of the troops without inflicting casualties on their own forces. This was the point at which strong German reserve forces might have halted the American advance.

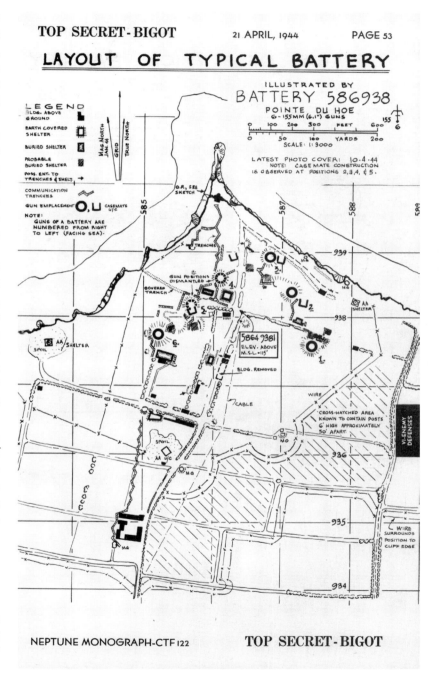

A plan of the German coastal battery at Pointe du Hoc (misspelt here as Pointe du Hoe). 2nd Rangers heroically climbed the cliffs to capture it, to save the fleet at Omaha from its 155mm guns. In fact, the guns had been moved further inland, and were found and disabled later that morning.

Around four miles to the west of the main landings at Omaha there was a German gun battery at Pointe du Hoc. Its massive concrete bunkers were believed to house six 155mm guns, with a range of fourteen miles. If not dealt with they could potentially shell Utah and Omaha beaches, as well as many of the ships offshore. It was located on a headland, protected on the seaward side by near-vertical cliffs 85-100ft high.

It had been decided to capture the site on D-Day to ensure that it was out of action. First it would be shelled by Allied warships. Then ten Royal Navy landing craft (many other landing craft crews at Omaha were also from the Royal Navy) would land 225 men of the US 2nd Ranger Battalion on a small beach below the battery. On D-Day several landing craft sank even before reaching the Pointe. The remaining Rangers climbed the cliffs under

This view of the fully developed US beachhead at Omaha illustrates the complexity of the D-Day plans, and the vast resources required to carry out the landings.

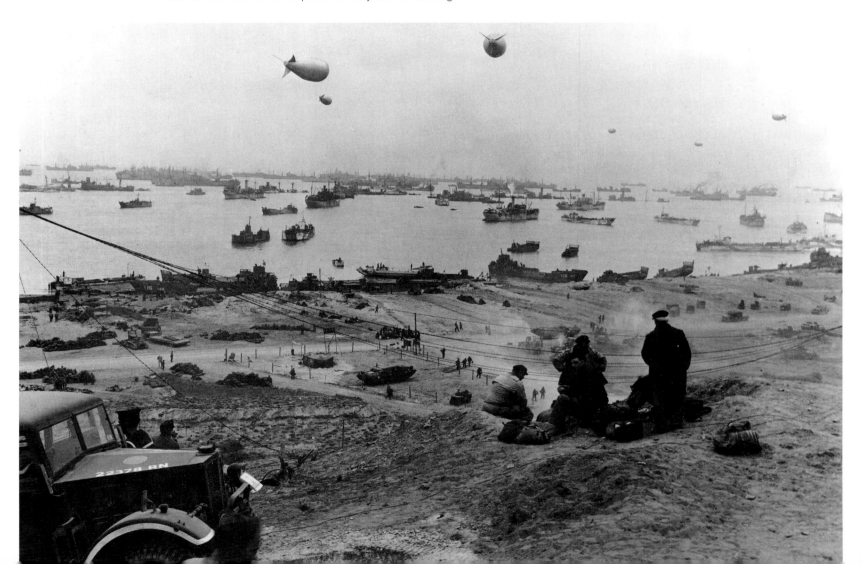

heavy fire from a garrison of 200 Germans above. Aided by fire from two destroyers, the Rangers reached the cliff tops only to find that the guns were not there. Later in the day the Rangers discovered the guns hidden in an orchard less than a mile inland, and destroyed them. The small Ranger outpost at Pointe du Hoc then held out for two days, losing around two-thirds of its 225 men as casualties. This valiant defence drew the attention of German troops who might otherwise have turned towards the main Omaha landings at the critical time.

Despite the detailed plan for Omaha Beach, wide use of radio equipment and the provision for observers to report back to headquarters, it was difficult for commanders offshore to work out what was happening on the beaches and how best to respond to it. The smoke of battle made it difficult to see what progress was being made on land or to identify the correct place for landing craft to beach. Senior officers who went ashore, such as Brigadier General Norman Cota, assistant divisional commander of 29th Division, were at times reduced to the methods of command of an earlier age: giving orders to men within shouting distance, and leading by example those who could see them.

Fortunately, the German commanders also found it difficult to get a clear picture of exactly where the Allies were landing and what was happening. A series of unexpected factors delayed German reactions to all the Allied landings on D-Day, and thus aided the Allied cause. Incomplete information about the extent of the landings, and the many false alarms of recent months, tended to make the various German headquarters adopt a 'wait and see' attitude rather than taking immediate action.

Rommel himself was absent from Normandy, as he had returned to Germany for his wife's birthday and an audience with Hitler. He was not the only senior German commander who was not at his post. The divisional commanders and some regimental commanders of the German Seventh Army (the garrison of Normandy and the surrounding region) were planning to take part in a war game at Rennes on 6 June, on the theme 'enemy landings in Normandy preceded by parachute drops'. For commanders in Normandy, Rennes was a distance of up to 100 miles away. Although Seventh Army's commander, General Friedrich Dollmann, had ordered these officers not to travel until dawn (just in case the Allies did land overnight), by midnight many of them were en route or even already at Rennes. As news of the Allied landings spread, these officers rushed back to their units. The commander of the German 91st Airlanding Division was in fact killed by American paratroopers in the early hours of D-Day as he was returning to his troops.

Almost as soon as the main bodies of airborne troops began landing in the early hours of D-Day, German troops in Normandy began to go on the alert. However, it was unclear exactly what was happening, and whether what was reported as airborne landings was in fact a minor raid or even just a feint to confuse the Germans, rather than a genuine all-out invasion. But raising the alert was not enough: the German defenders needed decisive orders.

At 3 a.m. the German Commander-in-Chief West, Field Marshal Gerd von Rundstedt, requested the use of three reserve divisions (Panzer Lehr, 12th SS Panzer and 17th SS Panzer Grenadier Divisions), which were under Hitler's direct control. Despite not receiving permission, just before 5 a.m. von Rundstedt ordered these troops to start moving to Normandy, but his orders were soon countermanded by the Army High Command.

Uncertain that the alerts were real, Hitler's staff did not wake him from his sleep until after Eisenhower had announced the landings on the radio at 9 a.m. Even then, Hitler would not take an immediate decision, and it wasn't until mid-afternoon that the German reserves finally received orders from Hitler's staff to proceed to Normandy. They faced Allied air attacks and many destroyed bridges on their route, which meant they took two days to reach Normandy in strength, so the twelve-hour delay early on 6 June was significant. The Panzer Lehr Division, for example, was a strong tank unit with 237 first-rate tanks and assault guns, and was only about eighty miles away from Caen in the Le Mans-Orleans-Chartres area.

With hindsight, the deployment of German troops at Omaha reflects the wider German debates on how troops should be used to meet an Allied invasion. In mid-March the German 352nd Infantry Division moved to the Omaha/Gold Beach area as part of Rommel's strategy of defending the coast in greater strength. The division also gained control of some troops from the neighbouring 716th Division, a lower grade 'static' unit. The commander of 352nd Division had different opinions from Rommel, however, and decided to have only two infantry battalions and one artillery battalion defending the beach area at Omaha (out of the available ten infantry battalions and five artillery battalions). Around one third of the division was near Isigny (around nine miles south-west from Omaha), and another third was in reserve twelve miles inland.

The 352nd Division's commander argued that such large reserves were necessary because he could not prevent a seaborne attack breaking through his defences. Rommel did not force the issue because in the German army such tactical matters were ultimately the responsibility of unit commanders. Yet, had the division been commanded by someone who shared Rommel's tactical ideas, Omaha Beach could have been even more heavily defended on D-Day.

To make matters worse for the Germans, on 6 June a large part of the division's reserves were sent further west to deal with landings by airborne troops (who turned out to be decoys and stragglers). At 7.35 a.m. part of the division's reserves were then sent to the eastern end of Omaha, but due to Allied air attacks did not reach their destination until mid-afternoon; the remainder were sent against the British advance from Gold Beach. Many of the division's other troops that had been based to the south-west of Omaha besieged the Rangers at Pointe du Hoc instead of marching to repulse the main beach landings.

If Rommel had convinced Hitler of his views on the use of reserves, Normandy would have been even more strongly defended on D-Day. Amongst his many unsuccessful requests for additional troops, in May

Rommel petitioned Hitler to bring the 12th SS Panzer Division under his direct control. This division was part of the reserve under Hitler's personal control, and was based around seventy miles east of Caen. Rommel asked that the division be transferred to the Isigny area, not far from Omaha. Fortunately for the Allies, this was a step too far for Hitler, and he would not release this division into Rommel's control. Both Utah and Omaha beaches would have been even more difficult for the Americans had such a powerful unit been based nearby.

By the end of D-Day the Americans had gained what would prove to be a sufficient foothold in Normandy. Much hard fighting still lay ahead, however, before the beachhead would be secure.

Many US airborne troops were scattered across a wide area on D-Day. These soldiers of the 508th Parachute Infantry Regiment, 82nd Airborne Division, are at St Marcouf, some twelve miles away from their intended drop zone. (Conseil Régional de Basse-Normandie / US National Archives)

US soldiers examine a Horsa glider in a Normandy field. The US 82nd and 101st Airborne Divisions used over 500 gliders on D-Day. The many small fields, and the obstacles put up by the Germans, often made it hard for glider pilots to land safely. (US Navy photograph)

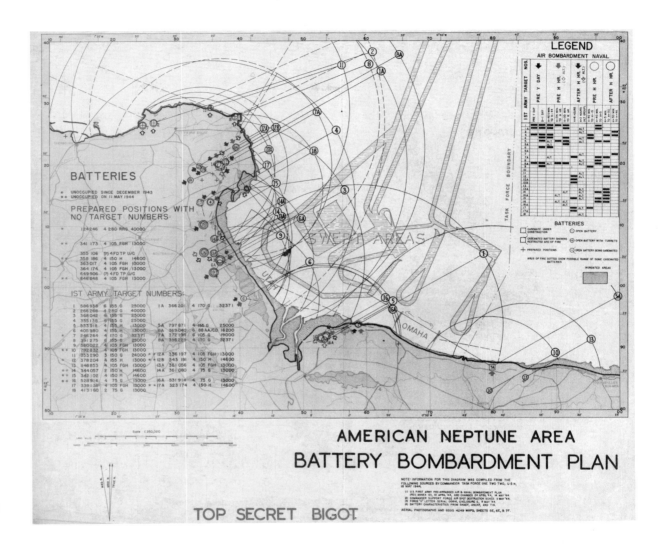

AMERICAN NEPTUNE AREA
## BATTERY BOMBARDMENT PLAN

TOP SECRET BIGOT

On this wartime map the thick lines travelling from the top right to the centre of the map are the channels swept clear of mines for shipping bound for Utah and Omaha. The curved lines are the arcs of fire of German gun batteries which, if not dealt with, could fire on much of the fleet.

## Who were the first troops to land by sea?

The first Allied troops to land by sea on D-Day did not land on the mainland of Normandy but on the Ile du Large, one of a group of islands called the Iles de St Marcouf which lay three miles off Utah Beach. The Allies were worried that the island was occupied by the Germans, and 124 men of the US 4th and 24th Cavalry Squadrons landed there at 4.30 a.m., two hours before the main landings at Utah and Omaha. They found that the island was unoccupied but the Germans had laid many mines there, which caused nineteen casualties on D-Day.

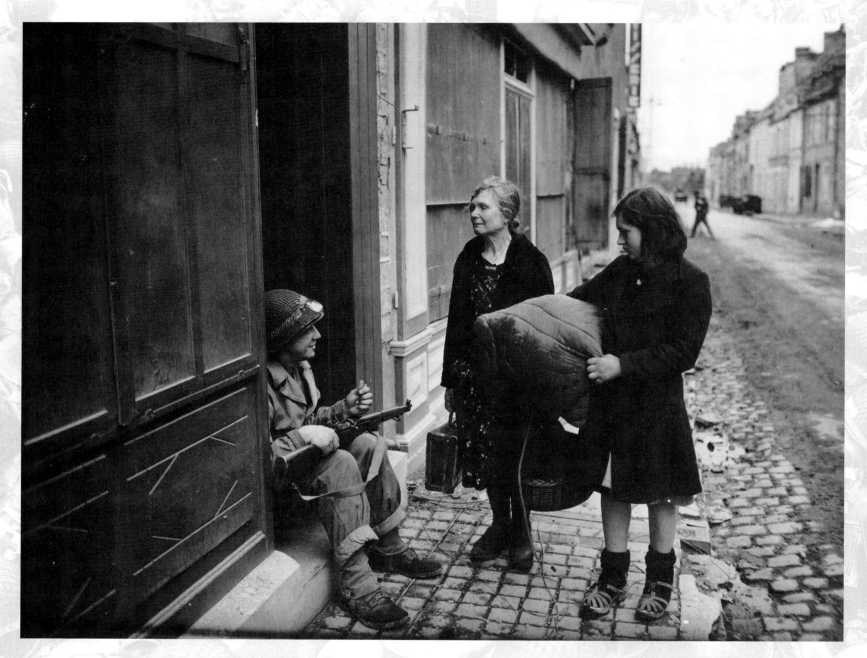

In the town of Ste Mère Eglise a US soldier talks to Madame Joan and her daughter. The lady's husband was killed by shellfire on 7 June. US 82nd Airborne Division landed in this area early on D-Day to gain control of local roads and bridges. Ste Mère Eglise was the first French town to be liberated. (US Navy photograph)

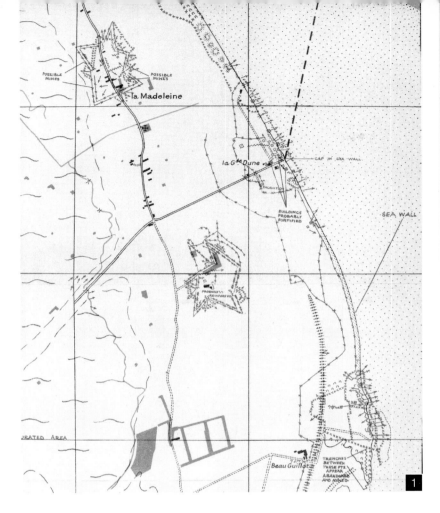

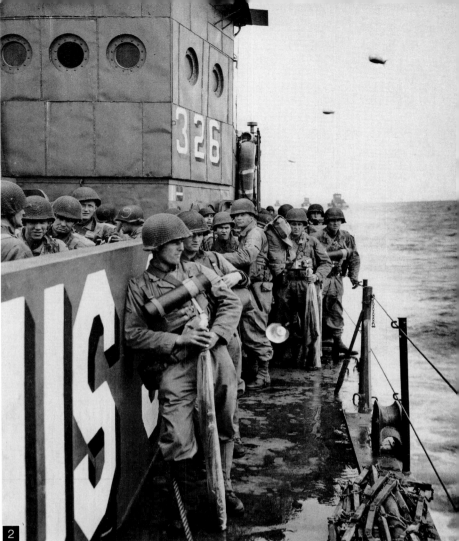

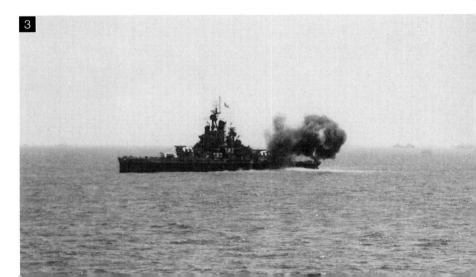

1 A detailed map of Utah Beach, showing German defences. The landings took place on either side of the dashed line, which marks the boundary between Tare and Uncle beaches. The beach was seized by US 4th Infantry Division.

2 US soldiers on board LCI(L) 326 – a Landing Craft, Infantry (Large) – on their way to Utah Beach. This was one of many craft manned by the US Coast Guard on D-Day. (US Coast Guard photograph)

3 USS *Nevada*, seen here, fired her 14-inch guns at the German battery at Azeville on D-Day. Despite the battleship's firepower the battery continued firing back at the landings, and remained in action until the German garrison was ordered to withdraw late on 11 June. (US National Archives photograph)

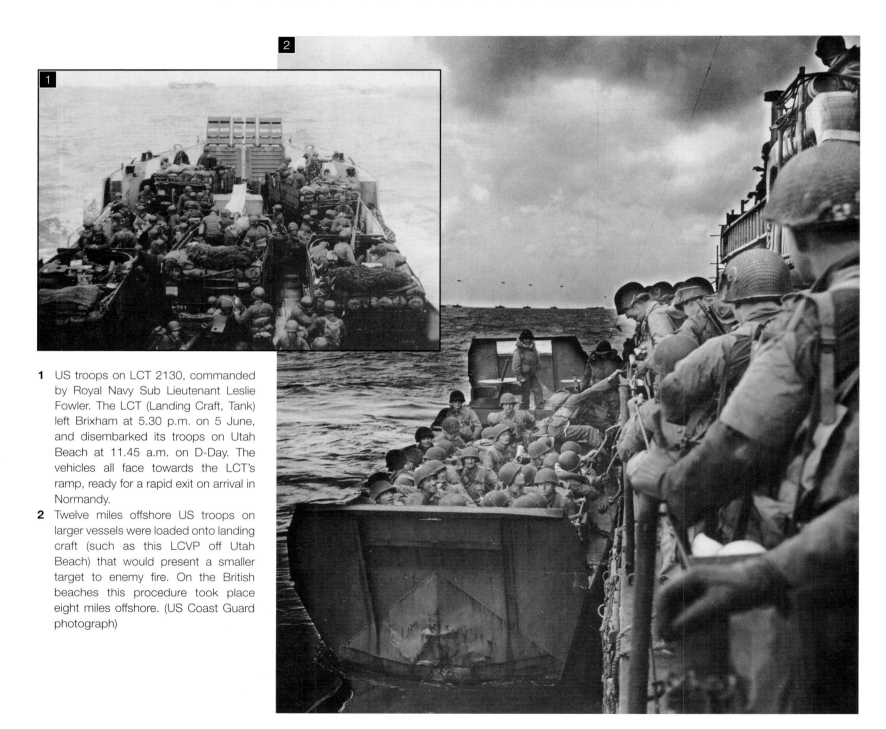

**1** US troops on LCT 2130, commanded by Royal Navy Sub Lieutenant Leslie Fowler. The LCT (Landing Craft, Tank) left Brixham at 5.30 p.m. on 5 June, and disembarked its troops on Utah Beach at 11.45 a.m. on D-Day. The vehicles all face towards the LCT's ramp, ready for a rapid exit on arrival in Normandy.

**2** Twelve miles offshore US troops on larger vessels were loaded onto landing craft (such as this LCVP off Utah Beach) that would present a smaller target to enemy fire. On the British beaches this procedure took place eight miles offshore. (US Coast Guard photograph)

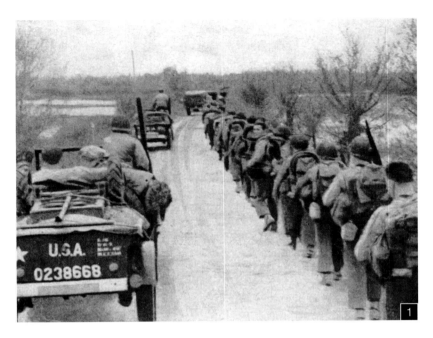

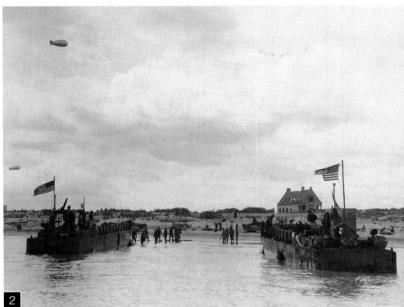

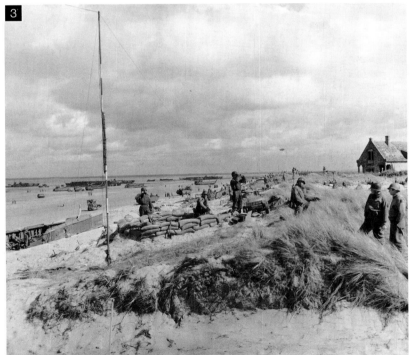

**1** The area behind Utah Beach had been flooded by the Germans. Here US infantry and jeeps advance inland up one of four causeways that crossed the floods. One of 101st Airborne Division's roles was to seize the far end of the causeways and prevent the Germans delaying the advance there.

**2** Two LCMs (Landing Craft, Mechanised) disembark troops on Utah Beach, at the north end of one of the German beach strongpoints, WN5. This photograph was taken on 8 June. (US Navy photograph)

**3** Four days after D-Day the atmosphere at Utah appears almost relaxed, since by this stage the fighting had moved further inland. One of the beach exits created through the sand dunes by US engineers on D-Day is in the immediate foreground. (US Navy photograph)

**1** Medics and signallers of 2nd Naval Beach Battalion at Utah. This unit ensured the smooth functioning of the beach area, including ship-to-shore communications, directing the movements of small craft, and casualty evacuation. It was commanded by the Beachmaster, who had responsibility for everything up to the high tide mark. (US Navy photograph)

**2** African-American soldiers disembark their Dodge Weapons Carrier from a Rhino Ferry. Rhinos were self-propelled pontoons, 41ft by 176ft in size, which were operated on all beaches. Vehicles or supplies from larger ships could be unloaded onto them, and then ferried onto dry land. (US Navy photograph)

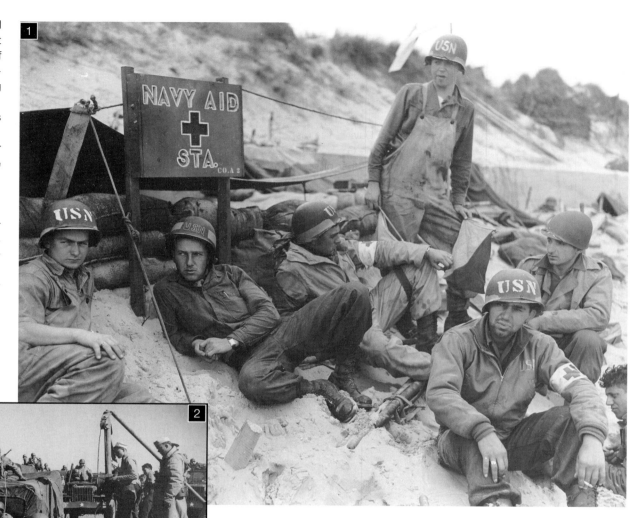

### Happy D-Day?

On D-Day the key German commander, Field Marshal Erwin Rommel, was at home in Germany for his wife's birthday – which by chance was on 6 June. He also wanted to meet Hitler to discuss defences in France. Rommel believed that over the next few days the weather would be too bad for an Allied landing. He did not return to Normandy until late on D-Day, so he was unable to organise the German defences at this vital moment.

**1** These soldiers of 101st Airborne Division, seen here at Carentan around 13 June, have commandeered a German Kübelwagen staff car. The capture of Carentan – achieved on 12 June – was a key step in the linking of Utah and Omaha Beaches. (Conseil Régional de Basse-Normandie / US National Archives)

**2** Omaha is the most infamous of the Normandy landing beaches, and was the scene of the heaviest casualties on D-Day. As the map shows, as well as the steep bluffs behind the beach, the Germans had added extensive defences. There were only a small number of vehicle routes off the beach, through what the Americans called 'draws', or ravines. Two US infantry divisions – 1st and 29th – landed on Omaha.

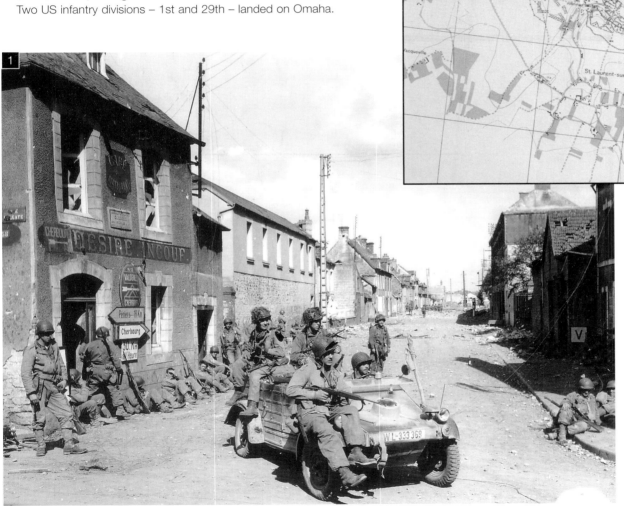

**2**

**OMAHA BEACH**

**KEY:**

⬅ FIRST WAVES

⬅ INITIAL ADVANCES INLAND
(ARROWS SHOW APPROXIMATE LOCATIONS AND DIRECTIONS ONLY)

1000 YARDS

2ND RANGERS

116TH INFANTRY REGIMENT

16TH INFANTRY REGIMENT

Vierville-sur-Mer

St. Laurent-sur-Mer

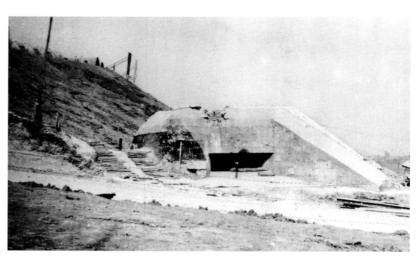

Fire support on D-Day was provided by many craft, including the LCT(R) or Landing Craft, Tank (Rocket), equipped with over 1,000 5-inch rockets. The rockets were intended to destroy barbed wire and minefields, and kill or stun German defenders. The sight of them being launched also boosted the morale of Allied troops.

This 50mm gun pillbox (seen here after D-Day) guarded the E-1 draw at Omaha, and was captured by 16th Infantry Regiment. The gun fired along the line of the beach, and was shielded from enemy fire on the seaward side by the wall projecting to the right of the photograph.

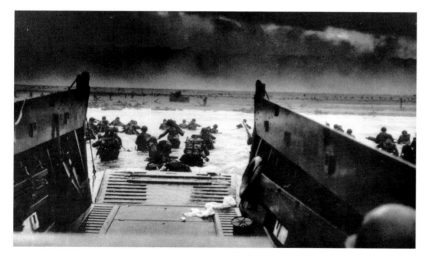

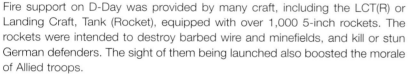

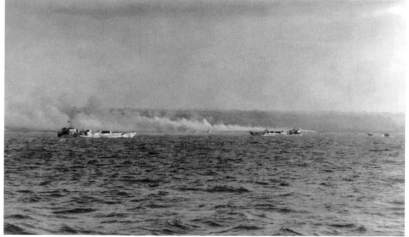

The same troops as shown in an earlier photograph leave their LCVP on Easy Red sector of Omaha at around 7.40 a.m. to 8 a.m. on D-Day, more than one hour after the first landings. At this point the success of the Omaha landings still hung in the balance. (Conseil Régional de Basse-Normandie / US National Archives)

This was the view of Omaha (specifically Dog Beach) that the US commanders had from their positions off the coast. Much of the beach area was covered with smoke from burning scrub and landing craft that had been set on fire, making it difficult to see what was happening on land. (US National Archives photograph)

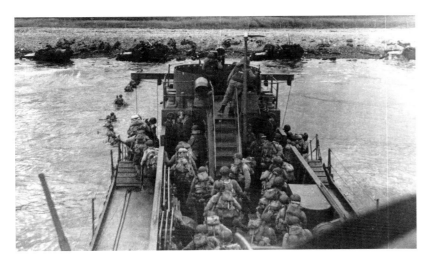

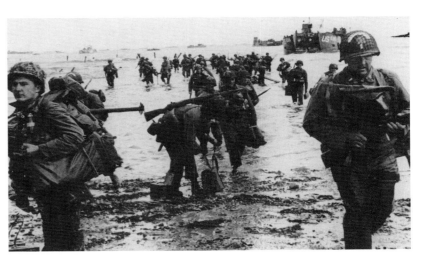

Troops land from LCI(L) 412, a Landing Craft, Infantry (Large). These vessels had a ramp either side of the bow for disembarkation, and were too large a target to take part in the very first waves of the landings. This is Easy Red sector, near Colleville.

Men of 5th Engineer Special Brigade come ashore at Omaha in the late morning of D-Day. The Engineer Special Brigades ensured that troops and supplies were moved inland off the beaches. Although all appears calm now, the photographer, Captain Herman Wall, was wounded twice shortly after this picture was taken.

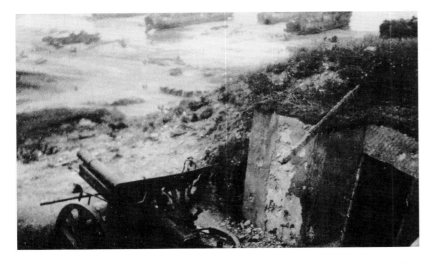

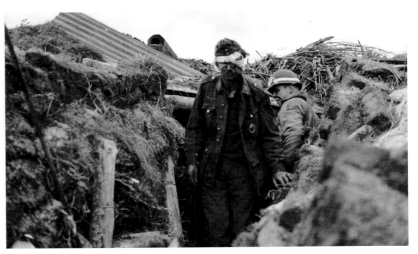

A German field gun, wrecked by Allied fire, in a defensive position overlooking Omaha Beach (ships can be seen at the water's edge, at the top of the photograph). The height that the US troops had to climb at Omaha is obvious. Photograph taken after D-Day by Lieutenant Trevor Wilson RNVR of LST 425. (Courtesy of Martin Wilson)

A wounded German soldier leaves his battered dugout under the watchful eye of an American military policeman. German soldiers along the beaches generally fought bravely until they were overwhelmed by the Allied forces. (US Navy photograph)

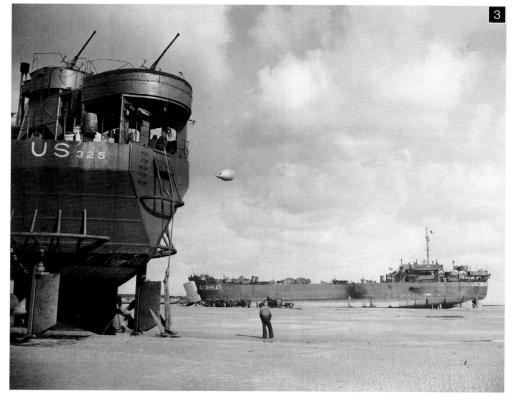

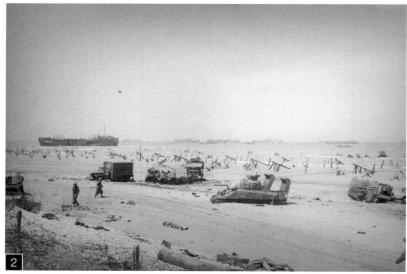

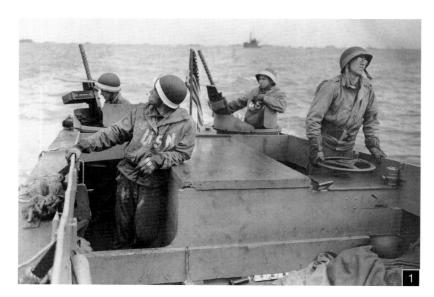

**1** The crew of a US Navy LCVP keep an eye open for enemy aircraft, 7 June. Such craft were constantly shuttling back and forth between larger ships and the beach, and were therefore continually at risk from mines, shells and obstructions. (US Navy photograph)

**2** The debris of war, probably at Omaha Beach, on 7 June. Many beach obstacles remain a hazard to any craft coming to the shoreline. The Sherman tank in the middle of the photograph has extensions fitted to its air intakes to allow it to wade through deep water.

**3** The LST – Landing Ship, Tank – could carry twenty Sherman tanks or around seventy lighter vehicles. In June delays in supply meant that some LSTs were beached, as seen here, and their sides cut open in order to speed up the unloading of desperately needed ammunition. LSTs were nicknamed 'large, slow targets' by their crews. (US Navy photograph)

# five

# 'DO NOT BE DAUNTED IF CHAOS REIGNS': THE BRITISH LANDINGS

From west to east British and Canadian forces of the British Second Army landed on Gold, Juno and Sword beaches. Although the troops were of different nationalities to the Americans landing at Utah and Omaha, the five Allied beaches were all part of the same plan.

The British and Canadian forces landed at several points along a twenty-five-mile length of coastline. To the west, troops from Gold Beach would need to fight their way through to link up with the Americans advancing from Omaha, about ten miles away. In the east the Caen Canal and River Orne (which ran almost parallel and close together) formed a natural barrier that could be used to protect the beaches. Even further east the Germans had allowed the Dives River to flood a large area, which prevented a further landing on that frontage.

In contrast to the steep bluffs of Omaha, most of the landing areas in this sector consisted of sandy beaches with small houses scattered along them. The area immediately behind the beach was generally flat, but further back there were low hills. Like any strong defensive position, the German defences in Normandy were based on a series of layers. Given the Allies' resources, it was unlikely that any part of these defences would hold out forever, but that was not the intention. Each layer was intended to delay the attacker and buy time for reinforcements to arrive.

As on the American beaches, the first layer of the defences consisted of strongpoints along the beaches some 2,000 metres apart and extending some 400 yards or more inland, each known as a *Wiederstandnest*. Each was generally guarding an exit from the beach that would need to be used by Allied vehicles to move inland. A *Wiederstandnest* usually incorporated beachfront houses turned into strongpoints, concrete bunkers and inter-connected trenches. The strongpoint would be manned by around thirty soldiers equipped with six to ten machine guns, several 81mm mortars and one or more anti-tank guns. In between the strongpoints were layers of barbed wire and minefields, and an attacker trying to cross these areas would come under fire from adjacent defences.

The second layer was formed from a line of strongpoints up to five miles inland and on higher ground. Not all of these had been completed by the time of D-Day but many that were established would cause considerable problems for the advancing Allies. The Hillman strongpoint behind Sword Beach held out until late on D-Day, while that at Douvres-la-Délivrande, behind Juno Beach, did not surrender until 17 June. Also positioned to the rear were the reserve troops and supporting artillery.

Relatively few German troops were defending the actual beach areas. At Gold and Juno there were three companies (each 100-150 men strong), and at Sword Beach there were two; at Utah and Omaha there were one and four companies respectively. A proportion of the troops were non-German, including members of several units of so-called *Osttruppen* (Soviet prisoners of war, forced to fight for the Germans).

Many of the troops landing on the Anglo-Canadian beaches had not seen action recently, if at all: for example, the majority of troops in both the British 3rd Division at Sword Beach and the Canadian 3rd Division at Juno. Despite this they were well trained, and in many cases had spent years honing the skills that would be used on D-Day. Among the British troops the 50th Division, 51st Highland Division and the 'Desert Rats' of 7th Armoured Division had great experience in the Mediterranean campaigns, and were brought back to the UK for D-Day to ensure the presence of more seasoned troops.

To deal with these defences, the Allies had available a vast range of firepower. As at the American beaches, in the early morning of D-Day heavy and medium bombers attacked the beach defences and the coastal gun batteries further inland, followed later by fighter-bombers. Then came a bombardment from warships' guns, rocket-firing and gun-equipped landing craft, and at the last minute even certain tanks and self-propelled artillery

fired their guns from their landing craft before the first troops landed. The fire of the warships' guns was directed by aircraft overhead and (once they had landed) also by specialist observers onshore.

Just as in the American sector, a rapid advance inland was vital for British and Canadian success. At each landing site certain units were tasked with making their way along the beaches, dealing with any remaining resistance (which in places went on well into the afternoon), while other troops pressed inland. In some places German strongpoint garrisons held out for hours despite being completely surrounded by Allied troops.

Key objectives in this sector were the city of Bayeux in the west and the city of Caen in the east (around six and ten miles inland respectively). If held by the Germans, both could form good defensive positions that would be difficult to capture. The major east-west roads in the area passed through both, and from Caen other roads radiated out across Normandy. Although it was possible to move troops off-road, it was much slower and unsuitable as a long-term solution.

After D-Day another objective would be to capture the area south of Caen that was suitable for the construction of airfields. Once aircraft could be based

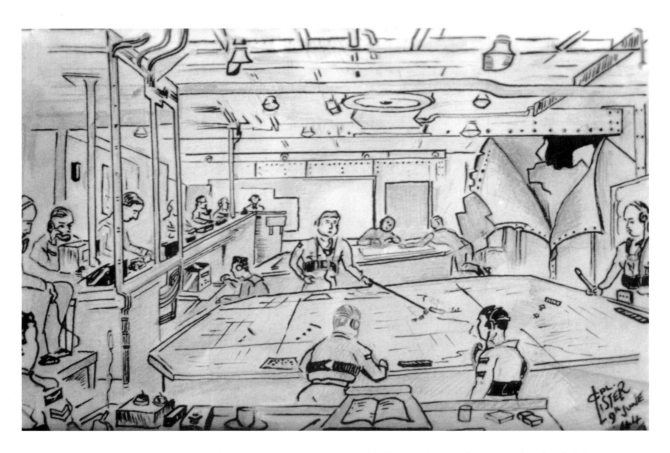

A sketch of the interior of the operations room on HMS *Bulolo*, the headquarters ship for Gold Beach. Not long after dawn on 7 June this ship was hit by a 250lb bomb that killed three men and made a hole in the side of this room (visible in the right-hand corner).

in Normandy itself rather than in the UK, they would be available to assist Allied troops much more rapidly, and would have the fuel to spend much longer in the air over the battlefield.

There were two German divisions in Normandy that Allied intelligence was unable to locate. Both were encountered by the Anglo-Canadian troops on D-Day. The German 352nd Infantry Division was defending Omaha Beach as well as Gold, and intelligence officers suspected that this division might be present but could not find any conclusive evidence. They believed that the other unlocated unit, 21st Panzer Division, was further away. In fact, that division was based around the city of Caen – the main objective for the troops landing at Sword.

The Allies' plan for D-Day itself was to capture both Caen and Bayeux, and if possible to send tank forces further inland (although this proved to be a little optimistic). British 6th Airborne Division would perform a similar role to the American airborne division in the west, protecting against German counter-attacks while the beach landings gained a foothold. Commandos would land on the beaches shortly after the first waves to deal with enemy defences on the flanks and carry out other specialist tasks. On Gold Beach, for example, No.47 Royal Marine Commando was to link with US forces from Omaha, as well as capturing the small harbour of Port-en-Bessin. From Juno, No.48 Royal Marine Commando would link up with No.41 Royal Marine Commando who would be performing the same function from Sword Beach.

Many of these Royal Marines and Army Commando forces suffered heavy casualties even before they had begun their main tasks. For example, three of No.48 Commando's six large landing craft hit beach obstacles as they landed, right in front of the German strongpoint at St Aubin. Despite not being in the first few waves of attackers, by the time its troops rendezvoused inland the unit had been reduced to 60 per cent of its original size.

There were a number of differences between the British and American plans. The planned landing times for the first troops were around an hour later (6.30 a.m. on the American beaches, 7.25 a.m. on Gold and Sword, and 7.35 a.m. at Juno). This meant that the preliminary bombardment from Allied warships, which began as soon as there was sufficient daylight to observe the targets, could last more than twice as long and therefore cause greater damage and disruption.

At all three beaches the British and Canadians made full use of 'Funnies'. These were tanks of the British 79th Armoured Division that had been specially equipped to deal with the German defences. Flail tanks, or Crabs, had a rotating drum on the front that cleared minefields in front of them.

Churchill AVRE (Armoured Vehicle Royal Engineers) tanks had a specialised gun that fired a powerful charge that was designed to destroy concrete bunkers. Some AVREs carried matting to enable vehicles to move over soft sand, a ramp that could be placed to enable other tanks to climb over the high anti-tank wall along the seafront, or a bundle of wooden stakes that could fill in a hole or ditch that was blocking the advance. Another specialist tank was the Centaur, manned by Royal Marines. The amphibious DD tanks have been mentioned already, as they were also used on the American beaches.

At several points on the Anglo-Canadian beaches on D-Day, a small number of these specialist tanks – or even a single one – that had landed around the same time as the first waves of troops, played a key role in dealing with surviving German positions that were causing heavy casualties and pinning down the infantry on the beach. The Funnies' role was to enable troops to get off the beach as quickly as possible. The advancing tide soon greatly reduced the amount of space on the beaches as the morning of D-Day wore on. Until the Funnies and other engineers could establish routes off the beaches and through the minefields and obstacles beyond, it was difficult for the troops to move inland.

The western half of Gold Beach, from Port-en-Bessin to Arromanches, could not be used for the landings because of high cliffs along the water's edge. Gold Beach was the landing site for troops of British 30th Corps, led by 50th Division. This division was reinforced with an additional infantry brigade (equivalent to the unit having a third more infantry than usual) as well as an armoured brigade.

Although the weather had been judged suitable to launch the invasion, the seas off Gold Beach were too rough for the amphibious DD tanks to take to the water and be first ashore, as intended. At Le Hamel 1st Hampshires (the lead troops of 231st Brigade) found themselves with little tank support, and were held up by heavy enemy fire while they were still in the water. Despite the Hampshires gradually managing to advance, small enemy strongpoints still held out in places until 4 p.m. To the east of the Hampshires, 1st Dorsets met less opposition. They were soon advancing off the beach, but met much more resistance as they moved inland.

To the east the first wave comprised 6th Green Howards (from 69th Brigade). Once inland they faced German fortifications at Mont Fleury, where a battery was under construction to house 150mm guns. Here Colour Sergeant Major Stanley Hollis won the Victoria Cross (Britain's highest award for bravery, and the only one to be won on D-Day) for several courageous acts that ensured the continued advance of his battalion and saved his men's lives.

On the eastern end of Gold Beach, 5th East Yorkshires landed at La Riviere, facing many machine guns from the fortified houses along the seafront, and were assisted by gunfire from warships and support craft. A concrete bunker holding an 88mm gun destroyed many of the supporting AVRE tanks, until a flail tank managed to fire into the bunker at close range.

By noon, apart from Le Hamel, most of Gold Beach was under British control. Later on D-Day 151st and 56th Brigades landed, tasked with advancing toward Bayeux and the Caen-Bayeux road. Bayeux could have been captured that night without a fight, but it was judged wiser to secure the ground that they had already captured. 50th Division did not quite achieve its Gold Beach objectives, but was to do so on 7 June with the capture of Bayeux and Port-en-Bessin (the latter by No.47 Royal Marine Commando after a courageous attack against strong defences).

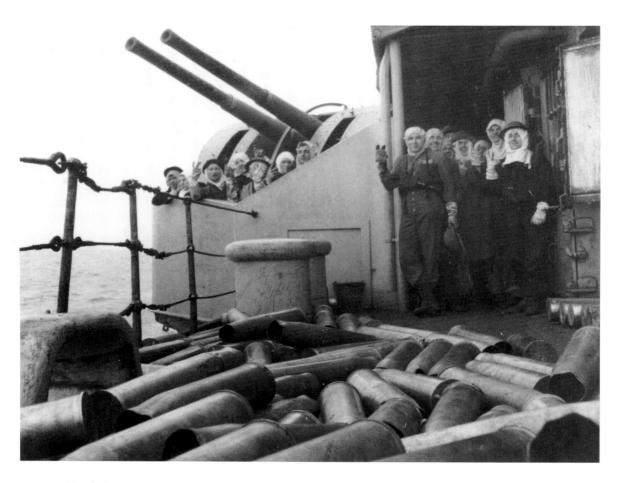

Royal Navy crewmen from a warship's 4-inch guns give victory salutes in front of a pile of empty shell cases. The scene is the result of an engagement against German E-boats (fast attack boats) off Sword Beach on D-Day.

Gold Beach's main objective was Bayeux in the west, while Sword's was Caen in the east. At Juno, located in between these two beaches, the objective was to seize the major road connecting Caen and Bayeux, as well as linking up with the British on either side.

As with the British on Gold Beach, the 3rd Canadian Division at Juno landed two brigades next to each other: 7th at Courseulles-sur-Mer and 8th at Bernières-sur-Mer. Although the main forces landing at Juno were Canadian, there were many British personnel among the supporting troops. The landings at both Sword and Juno beaches came under British First Corps.

The Juno landings were slightly delayed to ensure that the water over shoals just off the beach was deep enough; the shoals in fact turned out to be seaweed.

The Canadians landed slightly later than planned, at 7.45 a.m. and 7.55 a.m. on the two sectors respectively. Their landing craft came under fire well before touching down. The sea was rough and the beach obstacles were already being submerged. Landing craft had to disembark their troops amongst the obstacles in water that could be chest deep, or try and force their way in between them, at risk of sinking their wooden-hulled craft. The carefully planned landing sequence became jumbled as troops landed and many hit the mined obstacles with often devastating results. During the morning on Juno, ninety out of the 306 LCAs (Landing Craft, Assault – each with a capacity of thirty-five men) were lost or disabled, although not necessarily before being able to put their troops ashore.

By around 9.30 a.m. Bernières-sur-Mer was secure. Just after 11 a.m. the beach exit at Courseulles-sur-Mer had been cleared. Delayed by difficulties in getting off the beaches, by the end of D-Day the Canadians were still several miles short of the Caen-Bayeux road, and there was a two-mile gap between them and Sword Beach. The original aim of capturing Carpiquet Airfield (west of Caen) was not achieved.

To the far east of the beaches 6th Airborne Division landed before any other British and Canadian troops. Brigadier James Hill, commander of that division's 3rd Parachute Brigade, had given his officers some last-minute advice: 'Gentlemen, in spite of your excellent orders and training, do not be daunted if chaos reigns. It undoubtedly will.' These were to prove sound words. Just as with the US airborne troops in the west, many of the British airborne were widely scattered as they landed.

Arriving by parachute and glider, the division would seize the ground to the east of the troops advancing from Sword Beach, causing confusion amongst the German defenders and resisting any counter-attacks. Seizing the twin bridges over the Caen Canal and River Orne (code named Pegasus and Horsa respectively) was the first stage in this. It was not only important to deny the bridges to the Germans, but also to capture them intact (and the high ground to the east beyond them) so that Allied offensives could take place on the far side of the canal and river. Just as Allied success on D-Day would have been of no benefit had the beachhead not been defended on subsequent days, so the capture of the two bridges was only the start of the battle.

A force from 2nd Oxfordshire & Buckinghamshire Light Infantry under Major John Howard was tasked with taking these two bridges. Landing in five gliders (the sixth went astray) at sixteen minutes after midnight on D-Day, the bridges were captured in less than fifteen minutes. Not long afterwards troops from the main body of 6th Airborne began landing nearby, and were able to reinforce Howard's troops. Repeated German attacks on both the west and east sides of the men's position were repulsed. At midday Commando troops of 1st Special Service Brigade arrived, led by Lord Lovat and his bagpiper Bill Millin, having landed on Sword Beach that morning. Airborne troops also destroyed the bridges over the Dives River further to the east, sealing off that flank.

Equally as daring as the capture of Pegasus Bridge was the attack on the Merville Battery by 9th Parachute Battalion, commanded by Lieutenant Colonel Terence Otway. This German gun position lay on the far side of the Orne River. It was believed to be equipped with 150mm guns that could cause serious disruption on Sword Beach if they were not dealt with. The battery was surrounded by barbed wire 5ft high and 15ft thick, and was defended by minefields and machine-gun positions.

The intended assault force was 750 strong, most of whom would land by parachute. However, in the event many were scattered some distance away from their drop zones. In the end the attack was made with only some 150 available men, and without all the heavy equipment such as flamethrowers, mine detectors, mortars and anti-tank guns. Nearly half of the 150 became casualties, but the battery was successfully captured.

At Sword the width of the landing beach was restricted (by offshore rocks and by the estuary of the River Orne) so that only one brigade, not two as at Gold and Juno, was landed at once. The British 3rd Division would have had a better chance of reaching its main objectives and overcoming the difficulties that it had on D-Day had it not been able to land troops across a wider frontage, unrestricted by the terrain. The offshore rocks also resulted in a two-and-a-half-mile separation from the Canadians at Juno.

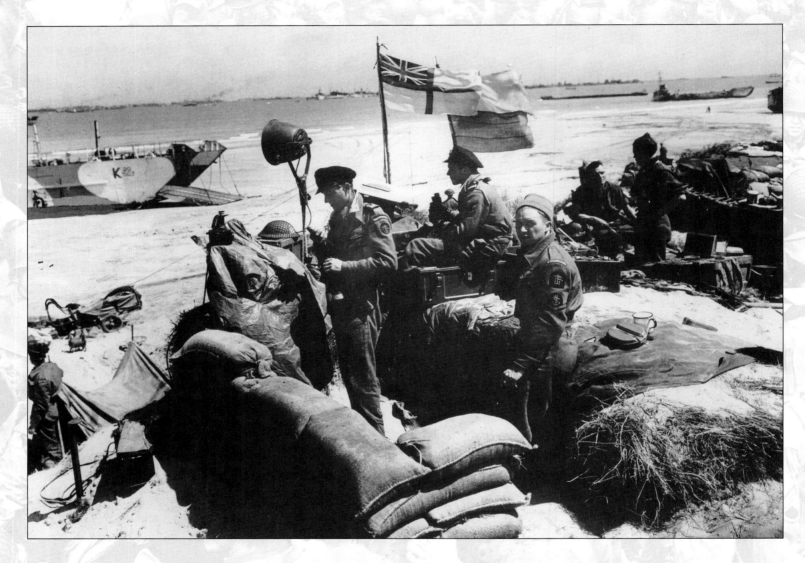

Members of the Beach Group at Juno. Each of the Anglo-Canadian beaches had a Beach Group, to ensure the smooth running of the landings there. The two Royal Navy officers in the centre have radios and a loudspeaker for issuing orders.

Of the forty amphibious DD tanks launched at Sword, thirty-one reached the shore. But they had been slowed by the rough seas, and rather than landing before the other troops they touched down around the same time as the infantry and other specialised tanks. 1st South Lancashire and 2nd East Yorkshire, from 3rd Division's 8th Brigade reached the beach at 7.25 a.m. at la Brèche. They met heavy fire from machine guns and anti-tank guns, and support from the British tanks was vital in overcoming opposition.

As on other Anglo-Canadian beaches, rough seas and the rapidly rising tide soon narrowed the beach. Until more beach exits could be cleared many of the division's tanks and other vehicles became stuck in a traffic jam, and were delayed from landing. The beach area was secured by 10 a.m., by which time other troops were already some distance inland. No.4 Commando and two troops of Frenchmen from No.10 (Inter-Allied) Commando headed east to pacify Riva Bella and Ouistreham, while 41st Royal Marine turned west to clear Lion-sur-Mer.

Inland from Sword were two major strongpoints known to the Allies as Morris (with four 105mm guns) and Hillman (a garrison of 150 men in underground concrete bunkers). Morris had suffered from recent bombardments, and surrendered easily. Hillman, in contrast, required a methodical attack by tanks and infantry that held up a significant part of 3rd Division for five hours. This strongpoint had been a target for the massed bombing raids early on D-Day, but had not been attacked because it had been hidden by low clouds. As well as halting the advance of the troops attacking it, Hillman also delayed troops who were trying to advance past it towards Caen.

About two miles away from Caen the British encountered tanks of the German 21st Panzer Division. At 7 p.m. around fifty German tanks from this unit advanced into the gap between Sword and Juno beaches. This was the major German counter-attack of the day, of a kind that could have happened at other points along the beaches had the Germans received sufficient warning of the invasion to bring some of their tank reserves forward. Part of the attack was turned back, the last straw for the attackers being the sight of over 250 gliders passing over their heads on the way to reinforce 6th Airborne Division.

By the end of D-Day the Anglo-Canadian forces had advanced an average of six miles inland. However, their position was not completely secure and links still had to be made between Juno and Sword and from Gold to the Americans. Caen had not been captured on the first day, but even if the British had reached Caen, they may not have been able to hold it.

Substantial forces had landed by sea: almost 25,000 at Gold, 21,500 at Juno and 29,000 at Sword – with roughly 3,000 casualties in total. Also landed

were 900 tanks and armoured vehicles, 4,500 other vehicles, 240 field guns, 280 anti-tank guns, and 4,300 tons of supplies and ammunition. Overall, the 6th Airborne Division had suffered around 10 per cent casualties on D-Day – 650 out of 6,250 men – but they had achieved all their main objectives.

Although the Anglo-Canadian troops had not achieved all their objectives, that certainly did not equate to a German victory either. The German 716th Static Division, defending the coast at Juno and Sword, was almost completely destroyed. 21st Panzer Division had not been able to direct its full power in a single direction, and had received considerable losses. 352nd Infantry Division had fought at Gold and Omaha, suffering heavy casualties, but was still able to fight on.

What explains the shortcomings of the German responses on D-Day? Of course, in analysing the actions of either side, one must not overlook that crucial element – the enemy. The weight of the Allied firepower, and the sheer numbers of Allied troops, were bound to overcome the German defenders in most places. That is not to say that the Allies relied on brute force, as opposed to skill and bravery, both of which were very much in evidence. There were many moments throughout D-Day when, to the Allied troops pinned down on the beach or in front of a strongpoint inland, it certainly did not feel like the Allies were winning. But through courage, teamwork and the skills that they had been taught during the long months preparing for D-Day, the Allied troops won through and advanced off the beach.

There are many cases of individual German units fighting effectively. Even many soldiers from 716th Infantry Division, a static unit whose troops included many older men, fought well on D-Day. The case of 21st Panzer Division illustrates some of the problems experienced by the Germans, which related to command and control, and uncertainty among the German commanders as to the best place to use reserves, rather than to a lack of bravery or the effectiveness of particular units. At the time of D-Day, the division was based around Caen, and was equipped with some 146 tanks, fifty assault guns, plus infantry, anti-tank guns and artillery. Whilst it was not the most powerful German formation in the region, it was certainly a significant force, and was well positioned to use its tanks to counter-attack Allied troops landing nearby. Yet, on D-Day, its actions were delayed and its forces divided in several directions.

At 1.20 a.m., only an hour after the 6th Airborne Division started landing to the north, the infantry defending the coastal zone requested assistance from 21st Panzer Division to deal with the paratroopers. The division's actions early on D-Day were hampered by the fact that the divisional commander was sampling the delights of Paris overnight, and then because

in Rommel's absence it was not clear who was responsible for giving the division its orders. Five hours later the order to move was given, and then at 8 a.m. the tanks finally got under way and began to move through Caen onto the eastern side of the River Orne.

At 10 a.m., as the threat of the beach landings became clearer, the division received orders instead to move the majority of its forces against Sword Beach. Since British airborne troops held Pegasus and Horsa Bridges (which otherwise would have been the most convenient route to Sword), this meant a long journey back through Caen and then to the north. During this move Allied aircraft destroyed many of the division's vehicles. By the time the division did attack towards Sword Beach, in the late afternoon, British troops had advanced inland enough to blunt the attack. Some German troops did manage to almost reach the sea, but not in enough strength for them to be able to remain there.

In strengthening the coastal defences of Normandy, the Germans aimed to create a layered system of strongpoints. Defences like Hillman, a few miles inland from the beaches, were designed to halt or at least slow up any attacker that managed to get through the coastal fortifications. By D-Day, however, the Germans had not been able to construct much of this second layer. Had there been a stronger German second defence line, and had units such as 21st Panzer Division been given counter-attack orders more promptly, D-Day would have been an even more severe test for the Allies.

On 7 June the remnants of 21st Panzer Division aimed to join with troops from 12th SS Panzer Division (which was beginning to arrive in Normandy from further east) to counter-attack against Sword and Juno. Fierce battles ensued that halted any significant Allied advances, but also prevented the Germans from gathering a large force of tank units for a counter-attack. This set the tone for much of the bitter fighting during the Battle of Normandy.

HMS *Argonaut* (with HMS *Ajax* just visible behind) fire at German positions at Vaux-sur-Aure and Longues respectively on D-Day. On all beaches naval gunfire support played an important role, both on and after D-Day. Photograph taken by A.B. Hill on HMS *Emerald*.

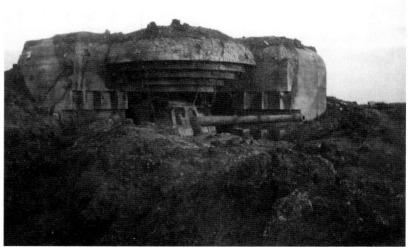

The four guns of Longues Battery were protected by concrete casemates (one seen here on 8 June 1944), and were situated roughly four miles west of the Gold Beach landings. Despite repeated bombardments from HMS *Ajax*, HMS *Argonaut* and other warships, on D-Day the battery kept firing at intervals for three hours.

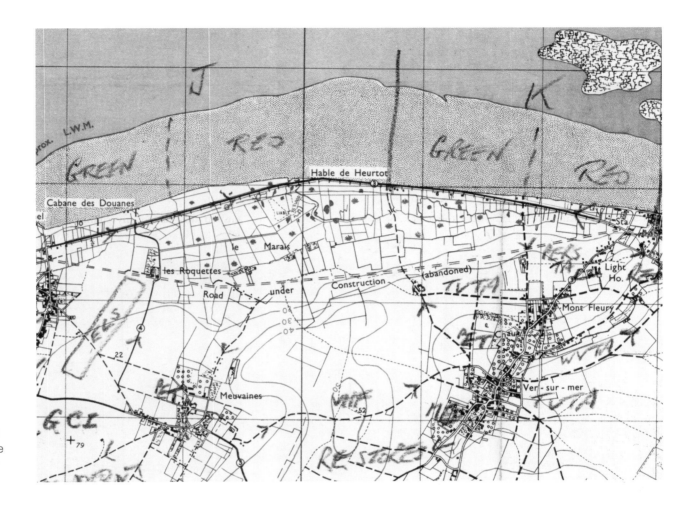

Detail of a map of Gold Beach showing Jig and King sectors (marked here as 'J' and 'K'). This map was used by L.A.C. Pratt of 152nd (Mobile) Anti-Aircraft Operations Room, and the other markings relate to the planned uses of this area after the fighting.

## The fake invasion

As the Allied convoys crossed the English Channel before D-Day, further to the north an 'imaginary' fleet was also setting sail. This consisted of a small number of Royal Navy vessels working with bomber aircraft of No.617 and No.218 Squadrons RAF, in what was known as Operations Taxable and Glimmer. The aircraft few in circles at low level, and with each circle they slowly moved closer to the French coast. As they went, they dropped aluminium strips known as 'window', which produced reflections on German radar that looked like a fleet of ships crossing the Channel. This was just one part of the Allies' deception plan aimed at convincing the Germans that they intended to invade northern France as well as Normandy.

Drawing showing troops crouched in a landing craft on their way to land on D-Day. The artist, Robert Rule, was a Royal Navy sick bay auxiliary on HMS *Empire Mace* at Gold Beach on D-Day. He based this drawing on accounts of the actual landings by Marines from his ship, and his own experience during practice landings.

Another drawing by Robert Rule showing a situation that happened to a fellow medic. With a patient who had serious facial injuries and breathing difficulties, the medic took a quick decision to carry out an emergency tracheotomy on the beach using a fountain pen with both ends snapped off – the only available equipment.

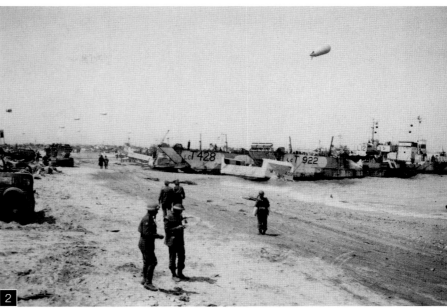

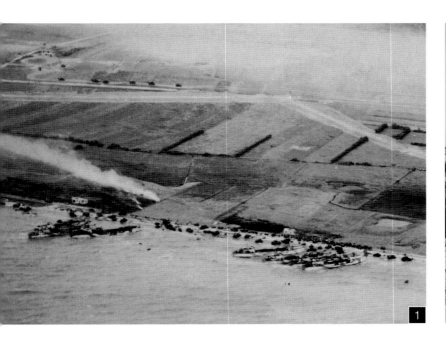

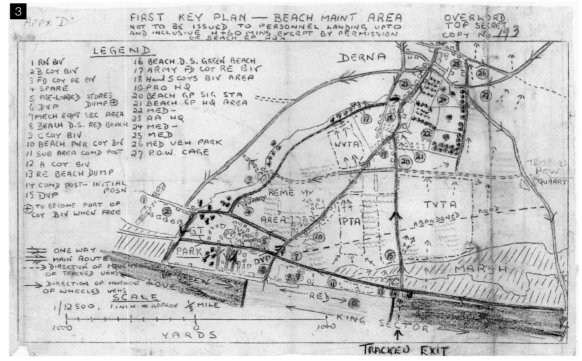

**1** An aerial photograph taken mid-morning on D-Day, showing King Green sector of Gold Beach, where 6th Green Howards landed. The tide has come far in, reducing the beach to a narrow strip of sand and slowing the process of unloading vehicles. The light-coloured line stretching across the photograph is an anti-tank ditch.

**2** With the worst of the fighting in the beach area over, landing craft start to unload vehicles and troops on Gold Beach (in the area of Ver-sur-Mer).

**3** Even before the fighting had finished, logistical services were starting to prepare different parts of the beachhead area for use as supply dumps, vehicle parks, prisoner-of-war compounds, etc. This hand-coloured map of 'Derna' (code name for Ver-sur-Mer) was issued to a member of the Beach Group at Gold.

## The sixth beach

The five beaches, from Utah to Sword, are well known. However, there was also a sixth beach that was potentially considered for landing, known as 'Band'. It lay to the east of Sword, on the far side of the Orne River. It was unusable because the Germans had flooded much of the area inland, and in any case the Allies did not have enough forces to land additional troops there also.

**1** A Frenchman distributes a welcoming drink to men of 1st Hampshires, in Arromanches on D-Day. The town was captured from inland rather than by an amphibious landing. After D-Day it became the centre of the British Mulberry Harbour. (Collection Musée du Debarquement, Arromanches)

**2** HMS *Princess Josephine Charlotte*, seen here, was a Belgian cross-Channel passenger vessel, converted to carry 247 troops and eight landing craft. On D-Day she and SS *Victoria* landed men of No.47 Royal Marine Commando. Of the fourteen landing craft from these two vessels, only two survived the landings unscathed.

**3** A drawing of Port-en-Bessin, from American naval orders for D-Day. This small fishing port, well defended by the Germans, was on the boundary between Omaha and Gold Beaches. It was captured by No.47 Royal Marine Commando on 7 June after a ten-mile march through enemy territory.

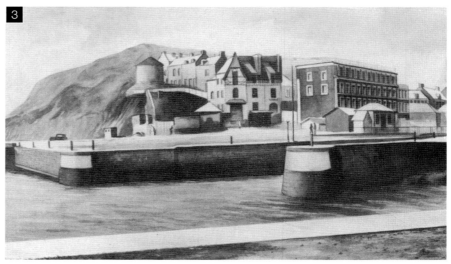

**1** Wartime map of part of Juno Beach, showing extensive beach obstacles at the water's edge. Troops of 3rd Canadian Division landed here, including Royal Winnipeg Rifles and Regina Rifles at Courseulles-sur-Mer (left), and Queen's Own Rifles of Canada at Bernières-sur-Mer (right).

**2** LCA 821 (a Landing Craft, Assault) lands Canadian troops of the North Shore Regiment at La Rive, Juno Beach. This is a still from a ciné film that was shown in cinemas as part of a *Pathé Gazette* newsreel on 15 June, which was one of the first shots of the initial landings to be seen by the British public.

**3** Men of the headquarters of 4th Special Service (Commando) Brigade land at St Aubin-sur-Mer on Juno Beach. The time is around 9 a.m. on D-Day. The man in the foreground features in the Overlord Embroidery, although minus his glasses. Behind him a lightweight motorcycle is being carried ashore. (© Trustees of the Royal Marines Museum)

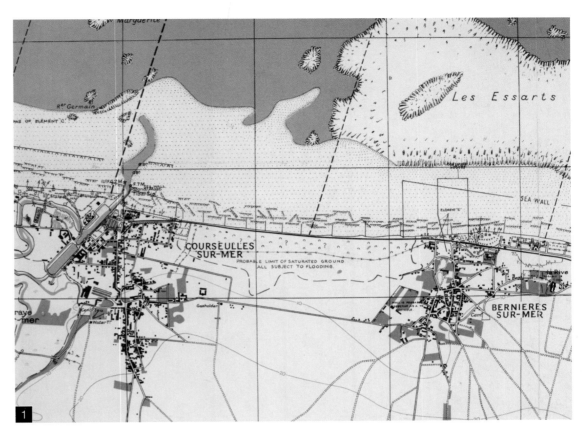

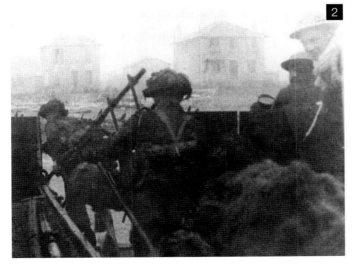

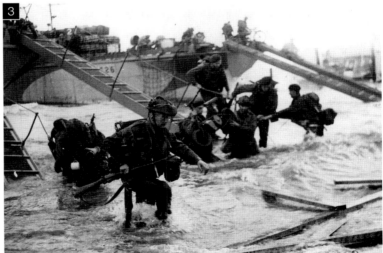

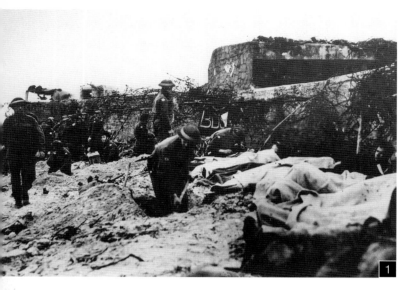

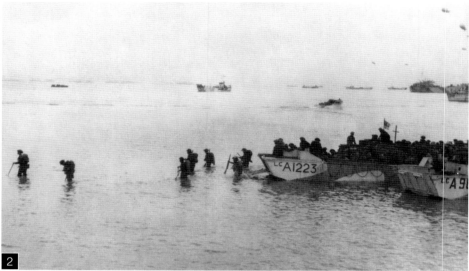

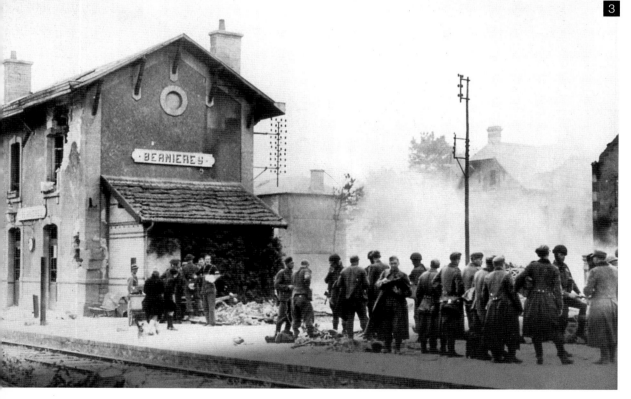

**1** After the capture of Nan White Beach (Bernières-sur-Mer) a medic treats the wounded and Beach Group troops dig foxholes for protection against shelling. The pillbox on the right housed a 50mm anti-tank gun and caused many of the sixty-five casualties suffered by the Queen's Own Rifles of Canada coming ashore here.

**2** Canadians of the Regiment de la Chaudière land from LCAs on Nan sector of Juno Beach at around 9 a.m. on D-Day. Photograph taken by S. Mincher, serving on LCT 1008.

**3** German prisoners of war are gathered on the station platform at Bernières-sur-Mer. Below the sign on the station building is a French boy, Jacques Martin, who had with him a trolley holding salvaged possessions from his family's home which had been destroyed by Allied shelling immediately before the landings.

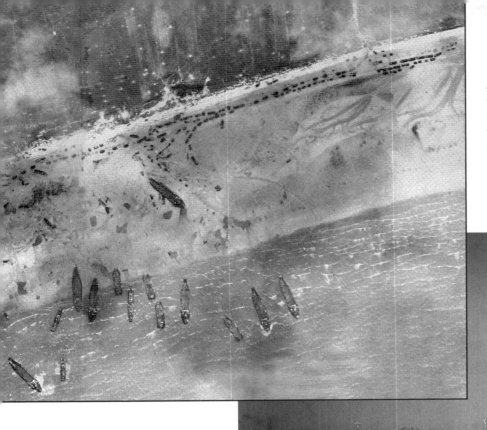

An aerial photograph taken at 3.20 p.m. on D-Day to the west of Courseulles (Mike sector, Juno Beach). Several larger landing craft have been stranded on the beach by the tide. Queues of vehicles wait to advance inland: the two beach exits at this point were blocked for some time by German obstacles.

Canadian soldiers land from LCTs on Juno Beach on the afternoon of 6 June. They are marching past a pile of 'hedgehog' beach obstacles onto a trackway made from wooden stakes. This is one of a relatively small number of colour photographs taken on D-Day. (Conseil Régional de Basse-Normandie / National Archives Canada)

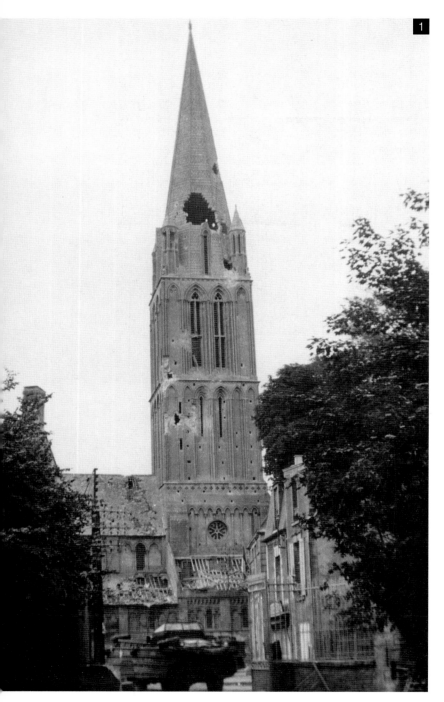

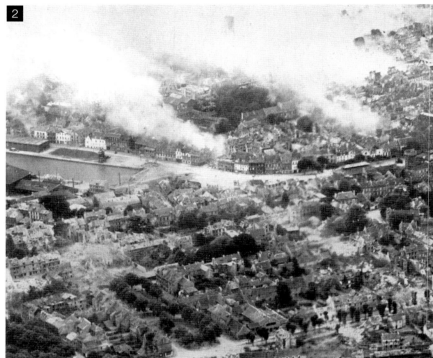

**1** The church at Bernières-sur-Mer was shelled by the Allies to drive out German snipers who were using it as an observation point.

**2** The city of Caen after Allied bombing on D-Day, which aimed to disrupt the movement of German reinforcements. Caen was again heavily bombed on 7 July to pave the way for the Anglo-Canadian offensive the following day. In fact the bombing made the city easier for the Germans to defend, and caused many French civilian casualties.

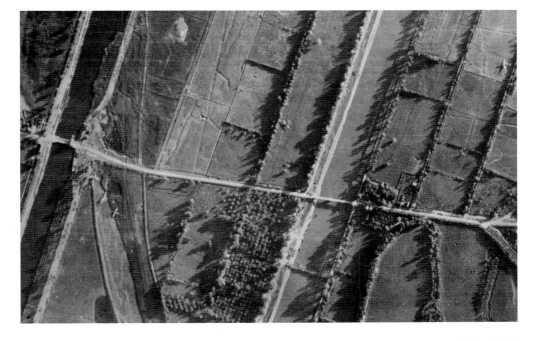

An aerial photograph of Pegasus Bridge at Bénouville (left) and Horsa Bridge at Ranville (right), across the Caen Canal and River Orne respectively. The two bridges were seized by British 6th Airborne Division as the first military operation of D-Day, to protect the eastern flank of the beach landings.

East of the beach landings, and a short distance inland, was the Merville Battery (seen on this wartime map surrounded by two rings of 'X's marking barbed wire, just above the letters 'R10'). The battery was captured early on D-Day in a heroic attack by 9th Battalion, the Parachute Regiment.

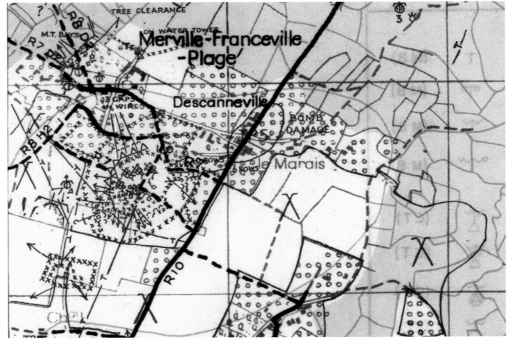

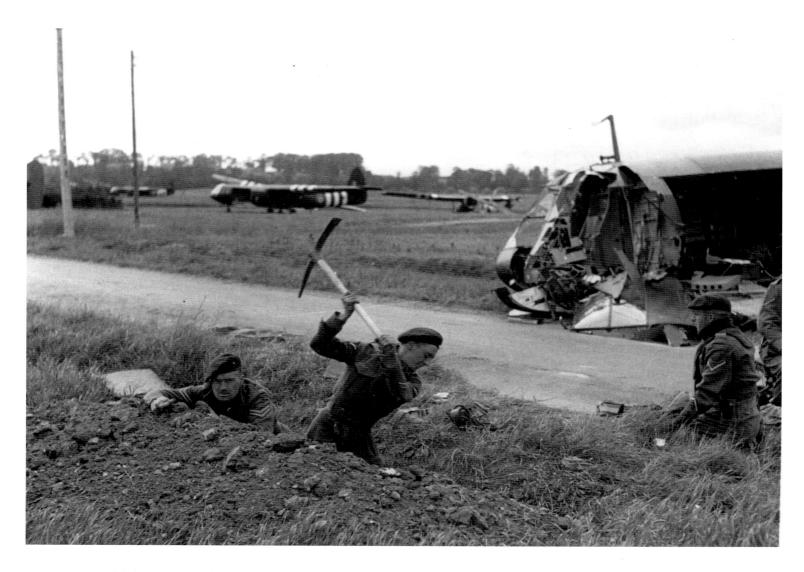

Marines of No.48 Commando dig foxholes for protection in the 6th Airborne Division landing area, not far from Pegasus Bridge, on 9 June 1944. They were relieving 12th Battalion, the Parachute Regiment. Horsa gliders that landed on D-Day can be seen behind them. (© Trustees of the Royal Marines Museum)

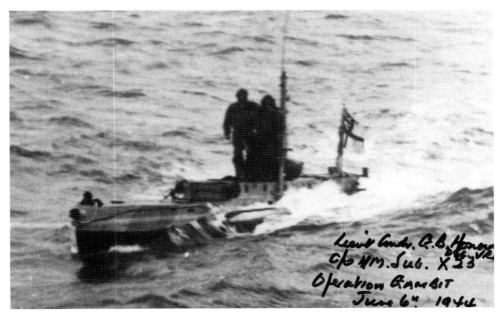

Two X-craft mini-submarines preceded the main invasion force, waiting off Gold and Sword Beaches for seventy-six hours (of which sixty-four hours were spent submerged). At 5 a.m. on D-Day they surfaced to provide additional navigation points for the Allied fleet. This photograph is signed by George Honour, who commanded one of them – X-23 – at Sword Beach.

A wartime map showing part of Sword Beach where the British 3rd Division landed. This area was designated Queen White (left) and Queen Red (right), with 1st South Lancashire and 2nd East Yorkshire being the first troops to land. The German strongpoint, code named 'Cod', was in the centre. It resisted strongly on D-Day.

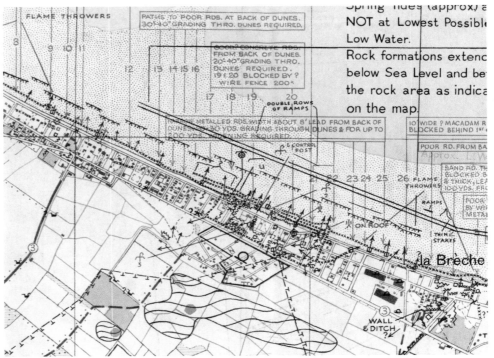

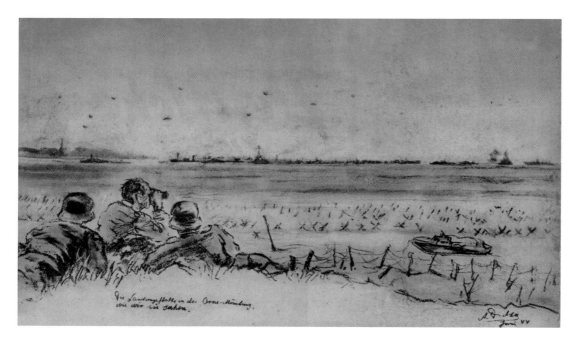

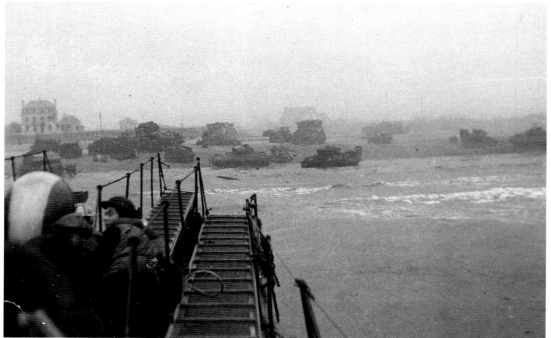

This drawing from the German air force magazine *Luftflotte West* is based on a photograph taken to the east of the Allied landings. It gives an impression of the sight facing the German defenders as the Allied fleet arrived off the beaches.

Vehicles of 27th Armoured Brigade on Sword Beach, seen from LCI(S) 519 – a Landing Craft, Infantry (Small) – that was about to land Lord Lovat and men of 1st Special Service (Commando) Brigade HQ. The LCI(S)'s landing ramps can be seen in the foreground. (© Trustees of the Royal Marines Museum)

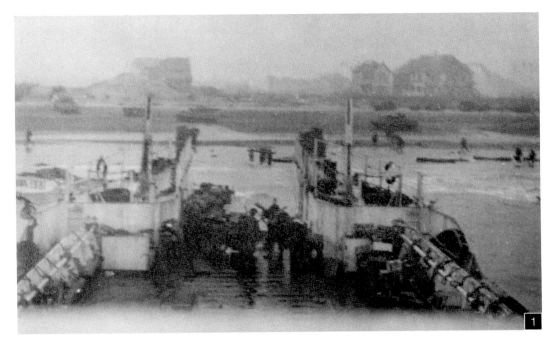

**1** LCT 979 (a Landing Craft, Tank) lands troops on Sword Beach. Many of the troops leaving this craft were killed by machine-gun fire before they reached dry land. The central figures near the water's edge are four Germans who wanted to surrender, but the LCT's crew would not take them prisoner. Photograph taken by Lieutenant P.W.D. Winkley RNVR.

**2** Queen White sector of Sword Beach, seen mid-morning on D-Day. This section of beach was lined with houses, each of which could potentially act as a strongpoint for German troops. The tide has come right in and many vehicles can be seen on the narrow strip of beach that remains.

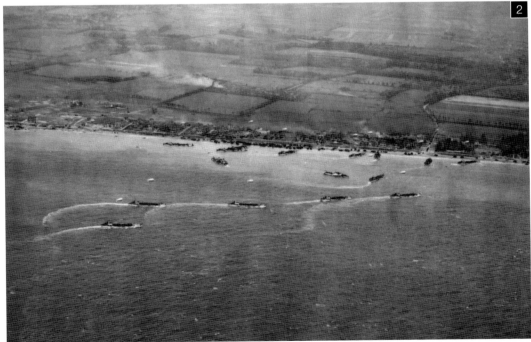

## How many Allied casualties were there on D-Day?

It has always been harder than you might expect to obtain an accurate figure for the total number of Allied casualties (killed, wounded, missing and prisoners of war) on D-Day. In the confusion of the day, many Allied personnel went missing from their units, sometimes temporarily or else because they had been killed in action. The Allied casualty figures for D-Day have generally been estimated at 10,000, including 2,500 dead. However, recent research by the US National D-Day Memorial has built up a list of individual names of Allied personnel who died at Normandy, and this has established that 4,414 men died on D-Day, of which 2,499 were American and 1,915 were from other Allied countries. For more information, see: www.dday.org.

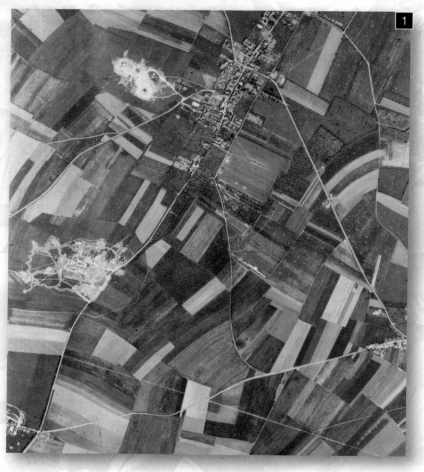

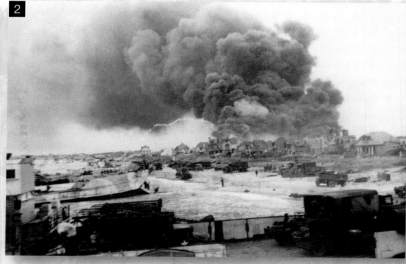

**1** Inland from Sword were two major strongpoints: Morris (top left) and Hillman (middle left). Morris surrendered rapidly, but Hillman required a methodical attack that delayed a significant part of 3rd Division for five hours. The tiny dots in the fields are anti-glider poles. The village at the top is Colleville.

**2** Sword Beach two days after D-Day. The smoke cloud was probably from an oil dump near the beach, set on fire by a German fighter-bomber. The small beachhead was so crowded that a bomb dropped almost anywhere within it was likely to damage some part of the Allied forces.

# 'YOU DON'T JUST WALK TO BERLIN...':
# THE NORMANDY CAMPAIGN

The long-awaited news of D-Day was solemnly received in Allied countries, with an awareness that there would be a period of bitter fighting before the war might be brought to an end. On the morning of D-Day, British radio carried announcements from General Eisenhower and leaders of occupied countries, including the Free French leader, General Charles de Gaulle. In other Allied states national leaders also spoke on the radio, warning of the hard fight to come but also of their confidence in the eventual Allied victory. In the USA, President Franklin Roosevelt warned against hopes for a quick victory, saying: 'You don't just walk to Berlin, and the sooner this country realises that, the better.'

The fighting from D-Day to the end of August 1944 is known as the Battle of Normandy. Allied success would depend on many factors, but one can pick two in particular. First were the skill, determination and bravery of the troops, particularly those who regularly came into direct contact with the enemy. The other key factor was logistics – in other words, supplying the armies. These two parts of an army are often known as the 'teeth' and 'tail' respectively, and each would have had little effect without the other.

In the six days after D-Day the Allies brought ashore 326,547 men, 54,186 vehicles and 104,428 tons of supplies. Everything that the Allied armies in Normandy required, from food to ammunition to fuel, had to be landed over the beaches. Consequently the naval forces continued to play a vital role after D-Day itself, and the Germans tried to sink supply ships or at least delay the rate at which reinforcements were landed. They laid pressure mines just off the Normandy coast, a type not used before. These were activated by a ship's wake, and forced all ships in the coastal area to travel at reduced speed. Midget submarines were also used to attack shipping off the coast.

The Allies had developed a sophisticated method of increasing the rate at which supplies could be landed in Normandy: the Mulberry Harbours. These were prefabricated, artificial harbours that were built in sections in the UK, and then were towed across the English Channel and assembled in position off the coast of Normandy after D-Day. Two were created: Mulberry A in the American sector at St Laurent, and Mulberry B under British control at Arromanches. They consisted of outer breakwaters, which sheltered floating piers and roadways onto which ships could unload their cargoes.

On 19-22 June a storm hit the Channel which caused problems for the Allied forces. Some 800 craft were thrown up on the beaches, and Mulberry A was damaged beyond repair before it had been put into full operation. The number of troops being landed stood at 80 per cent of the planned figure, and only 61 per cent of the required supplies were yet ashore. The shortfalls in supplies meant that desperate measures had to be taken. Holes were cut in the sides of certain ships carrying ammunition, to speed up unloading: damaging the ship was less important than continuing the ammunition supply.

There is no doubt that the Mulberry Harbours were an impressive engineering feat. However, some historians now question whether they justified the huge resources used in their construction: 30,000 tons of steel and concrete, and a workforce 45,000 strong. In ten months of operation, 2.5 million men, 500,000 vehicles and 4 million tons of supplies landed at the Arromanches Mulberry. Fortunately for the Allies it also proved possible to land cargoes directly onto the beaches at a faster rate than predicted.

Another great engineering achievement associated with D-Day was PLUTO, which stood for Pipeline Under the Ocean, and was a method of moving fuel over to the Continent. Specially developed 3-inch-diameter pipes would be laid across the Channel, and connected to the overland fuel pipeline systems on either side of the sea. It had been intended that the first PLUTO pipeline would be laid eighteen days after D-Day, from the Isle of Wight (just off the south coast of England) to the port of Cherbourg in Normandy. Delays in the capture of Cherbourg, and technical problems with

the pipeline, meant that PLUTO did not operate until 22 September. Just over a month later a new route was opened from Dungeness in Kent across to Boulogne. For a while PLUTO pumped 1 million gallons per day (equivalent to 250,000 jerry cans). Due partly to the delays, however, only 10 per cent of the fuel used from D-Day onwards went via PLUTO.

The fighting in Normandy was shaped by the terrain. Across much of the battlefield – on both the American and the Anglo-Canadian fronts – there were many small fields bordered by thick hedgerows, and small villages with sunken lanes leading between them, creating a landscape known as the bocage. It was difficult to co-ordinate the movement of troops, who were vulnerable to ambushes. New tactics and equipment had to be created to deal with these conditions, such as metal 'teeth' that were added to the front of some American tanks to enable them to burst through the earth banks.

Around twenty miles south of the Anglo-Canadian sector was the so-called Suisse Normande ('Norman' Switzerland), with many wooded hills and ridges. To the south and south-east of Caen the countryside was much more open, and both sides used (or hoped to use) their tanks here en masse.

Some historians have suggested that the Allies' preparations and training focussed on the beach landings and did not consider the tactics that would be needed in the bocage. They concentrated on D-Day itself – the first problem that they had to face, and one that was reasonably well understood – rather than circumstances that might or might not occur afterwards. Allied planners optimistically hoped that there would be a quick advance through the more difficult terrain behind the beaches, and into the more open countryside beyond.

The close-in terrain certainly aided the Germans, who were on the defensive for most of the fighting. The frontline of a German position was normally held by few men (supported by many machine guns and mortars), with the majority of their troops positioned further back. As Allied soldiers advanced, they would often come under fire from behind from scattered German troops who had hidden as they went past, or would be counter-attacked by German reserve forces. Tanks and infantry frequently became separated in the advance

The June 1944 issue of *De Frie Danske* (The Free Dane), an underground newspaper secretly produced in German-occupied Denmark. The cover shows an American and a British soldier, marking the beginning of the liberation of Europe. D-Day gave hope to countries occupied by the Germans that freedom would eventually come.

and could not support each other. Infantry were vulnerable to enemy tanks, unless thick vegetation meant that they could creep up close to them. Tanks were a powerful weapon but were vulnerable to being ambushed by carefully camouflaged tanks or anti-tank guns, against which they needed assistance from the infantry. Aircraft and artillery were both often called upon to pave the way for an attack or when Allied troops met heavy resistance. The Allies had enough aircraft that at any moment in daytime (weather permitting) some could be in the air in a so-called 'cab-rank', ready to appear in support of ground troops whenever they were called for.

Artillery and mortars (firing at longer and shorter ranges respectively) were vital in supporting other troops. Allied attacks often followed behind an artillery barrage – a line of bursting shells that would slowly advance through the enemy positions. Yet, while the artillery might enable Allied troops to advance, it would fall to the infantry to hold the newly gained position and defend it against counter-attack. Enemy artillery was also a frequent cause of breakdowns in communications. Radio transmissions from headquarters might be detected and their position shelled. The wires connecting field telephones were often broken by shelling (or by friendly vehicles driving over them). Despatch riders and messengers also became casualties and messages were lost.

A significant proportion of casualties suffered from 'battle fatigue', in other words the psychological effects of intensive warfare (the proportion rose to one in four casualties in July). Where possible, armies attempted to give their troops regular if brief rests, and facilities such as baths or entertainment, to help the troops deal with the stress of battle.

The safest place to be was below ground, and if troops stopped for long they would dig two-man foxholes. If the enemy was nearby, leaving the foxhole in daytime could be a great risk. Life in Normandy for the Allied troops generally revolved around the soldier's immediate unit, of perhaps ten or twenty troops. These men became like family to each other, forming bonds of comradeship that continue to this day, and that were vital in supporting each other through the trauma of battle.

A page from the June 1944 diary of seventeen-year-old David Bright from Exeter. The news of D-Day was received with excitement throughout the Allied countries, but also with concern for the long fight ahead. As the diary shows, ordinary life – including homework and trips to the cinema – still went on.

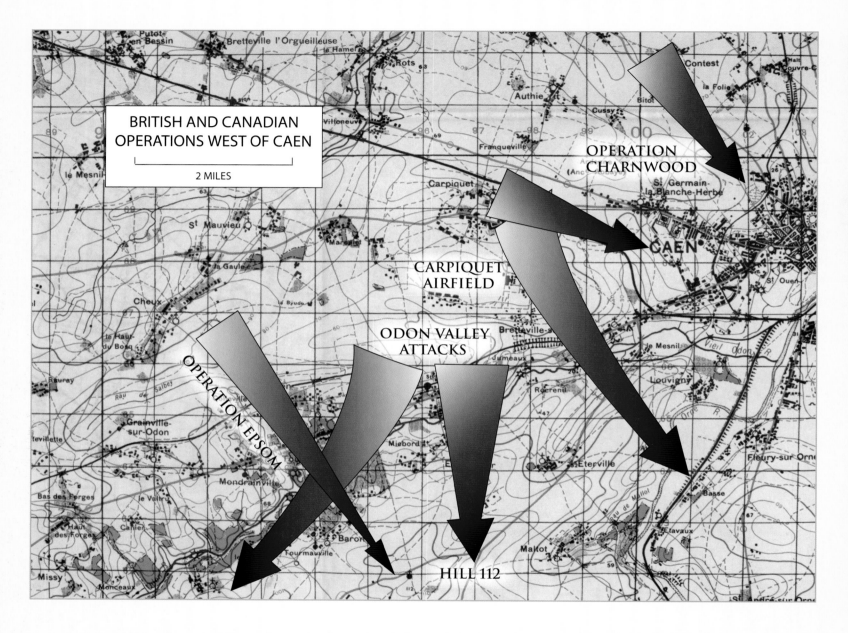

BRITISH AND CANADIAN
OPERATIONS WEST OF CAEN

2 MILES

OPERATION
CHARNWOOD

CARPIQUET
AIRFIELD

ODON VALLEY
ATTACKS

OPERATION EPSOM

HILL 112

The area west of Caen witnessed a fierce struggle between the Anglo-Canadians and the German defenders. Carpiquet Airfield saw bitter fighting between the Canadians and SS troops. Key Allied offensives in this area included Operation Epsom (24-30 June) which reached as far as the strategic point of Hill 112) and Operation Charnwood (7-9 July) which saw the Allies reach Caen. They were followed by attacks down the valley of the River Odon (10-18 July) to draw off German reserves prior to the next offensive to the east of Caen (Operation Goodwood).

**1** Massive daytime raids by Allied aircraft were a feature of several offensives during the Battle of Normandy. This and the following two drawings were done at the time by Alan Ritchie, serving with the Royal Electrical and Mechanical Engineers (REME) in 7th Armoured Division.

**2** Tanks move up for the offensive. The constant movement of vehicles, with Allied aircraft overhead and a backdrop of orchard trees, were all typical scenes in Normandy. Drawn by Alan Ritchie.

**3** Although the German air force rarely showed itself during the daytime, night raids were more frequent, as shown in Alan Ritchie's drawing. So-called rear areas were not necessarily safe. Night bomber aircraft were known as 'bed check Charlie' because they often appeared as the Allied troops were going to sleep.

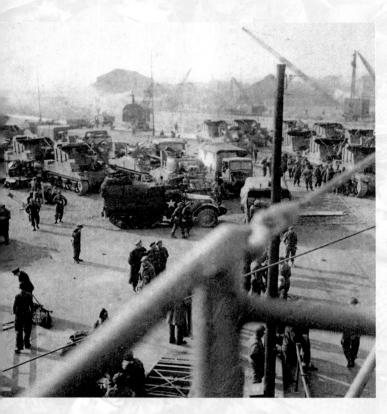

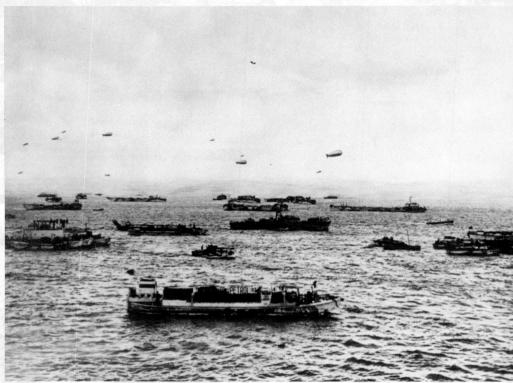

After D-Day itself the Allies had to bring troops to Normandy faster than the Germans could bring in reinforcements. Here vehicles of 13th Regiment, Royal Horse Artillery, load at Tilbury on 12 June 1944. They belonged to 11th Armoured Division. Photograph taken by Lieutenant R.H.C. Probert.

A selection of the many types of specialised landing craft and other vessels can be seen here. In the foreground, a Landing Barge, Fuel; behind it and to the left, a Landing Barge, Kitchen; further back, several of the ubiquitous LCTs (Landing Craft, Tank) – all protected against air attack by barrage balloons.

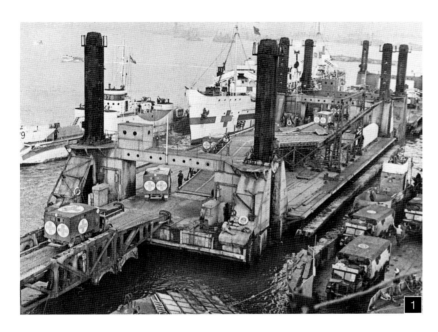

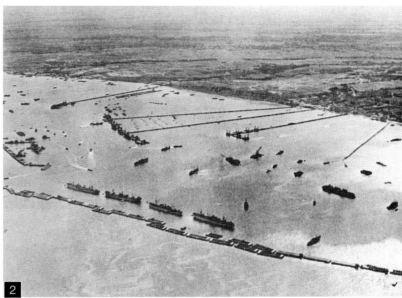

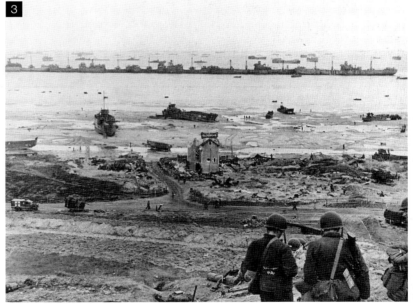

**1**  A hospital ship and other vessels alongside one of the Mulberry Harbour pierheads. The tall legs at the corners of each pierhead rested on the sea floor, and the platform on which ships unloaded would float up and down, so that it could operate at all stages of the tide.

**2**  The Mulberry Harbour at Arromanches. During the ten months after June 1944, 2.5 million men, 500,000 vehicles and 4 million tons of supplies landed here.

**3**  A 'Gooseberry' breakwater was built off each of the five beaches (this is at Laurent-sur-Mer, on Omaha Beach). The Gooseberries were formed from redundant ships, which were sunk in lines just off the coast, thus providing shelter for smaller vessels. They sheltered many small craft during the great storm of 19-22 June.

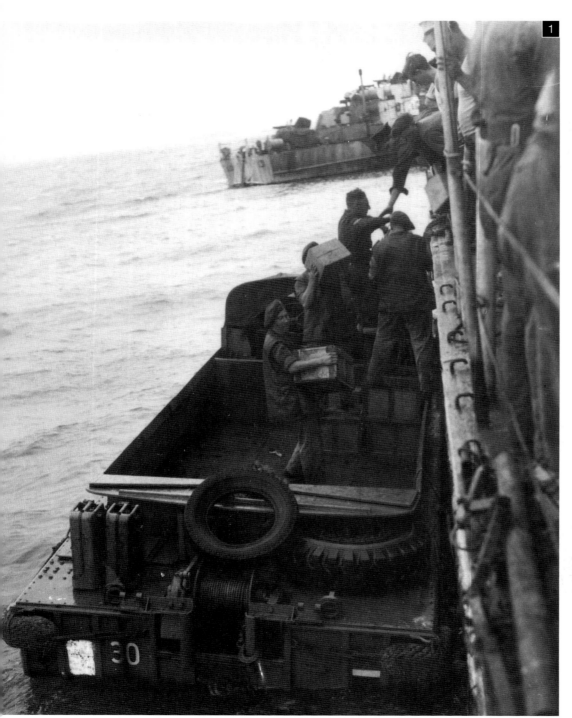

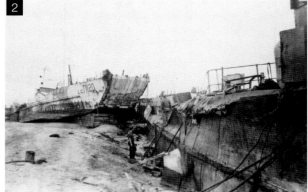

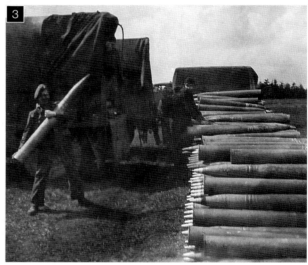

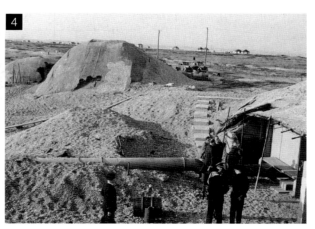

**1** Transfer of supplies between a DUKW amphibious vehicle and a ship at sea. DUKWs sped up the process of unloading because they could carry material straight from a ship in deeper water onto land, right up to the troops or supply dumps where they were required. (Courtesy of *The News*, Portsmouth)

**2** Two LCTs thrown onto the shore and wrecked during the storm of 19-22 June. The storm caused major delays in landing troops and supplies, and at least 800 ships and small craft were run aground.

**3** Driver Ken Pitt of 7th Armoured Division manhandles a huge shell at a supply dump somewhere in Normandy. Allied success in Normandy depended on logistical power as well as the bravery of the troops.

**4** Part of the pumping station for PLUTO (Pipeline Under the Ocean) at Dungeness in Kent. Seventeen pipelines (like the one in the foreground) crossed the Channel from here to Boulogne in France, carrying fuel and oil for the Allied armies. Four lines went from the Isle of Wight to Cherbourg. PLUTO first began operating on 22 September 1944, later than originally intended.

**5** A US Navy medic writes a letter from a well-built foxhole on Utah Beach. Contact with family and friends back home was important for sustaining the morale of the troops. (US Navy photograph)

**6** Three Military Police personnel in Normandy: Lance Corporal Martin (on motorcycle) talks to Corporal J. Collins and Lance Corporal C. Strong of the Auxiliary Territorial Service (ATS), who have just landed at Arromanches as part of the first ATS contingent in France. The Military Police helped with the smooth running of the beachhead.

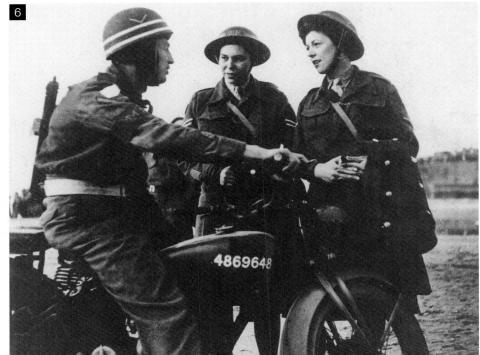

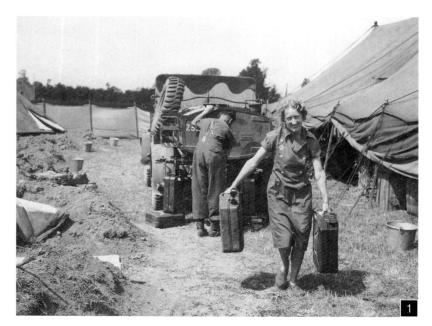

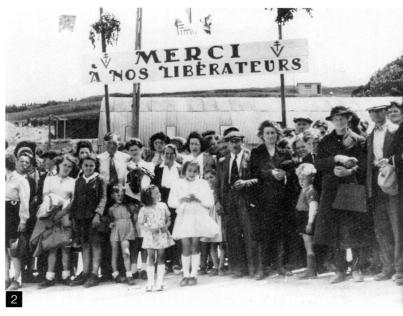

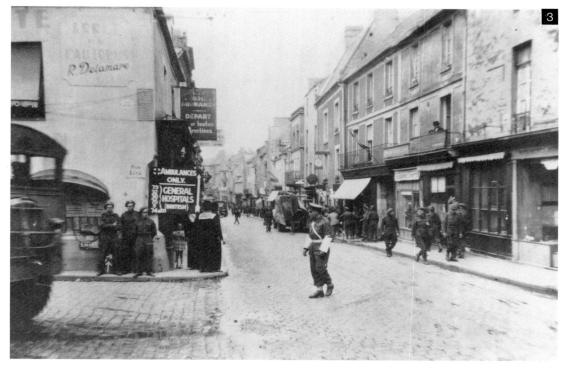

**1** A NAAFI worker in Normandy carries water from a 200-gallon water truck. Even near the frontline the NAAFI provided food and drink and a place for troops to relax.

**2** Local people display a sign proclaiming 'Thank you to our liberators' at a ceremony in Arromanches, some time after the landings. Many French people lost their lives or property during the Battle of Normandy, but generally the arrival of the Allied troops was welcomed. (Collection Musée du Debarquement, Arromanches)

**3** A Military Policeman directs traffic in the streets of Bayeux. Soon after D-Day, Bayeux became a major logistical and administrative centre for the Allied forces, surrounded by supply dumps, hospitals and other facilities. A circular road was built around the city, as its narrow streets were not suitable for convoys of military vehicles.

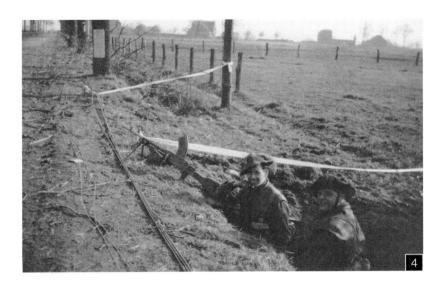

**4** Men of the Lancashire Regiment occupy a foxhole. They have been captioned by the photographer, Edwin Crowe, as 'forward infantry'. Infantrymen in the frontline areas usually dug foxholes like this in pairs.

**5** A group of happy British soldiers with a goose that they are about to cook. Fresh food was often not available to frontline troops. (Photograph by Edwin Crowe)

**6** Another photograph by Edwin Crowe, captioned 'arch looter'. Allied troops seldom wasted opportunities to supplement their army rations with whatever else they could find. When searching an abandoned building like this one, however, they had to watch for booby traps left by the Germans.

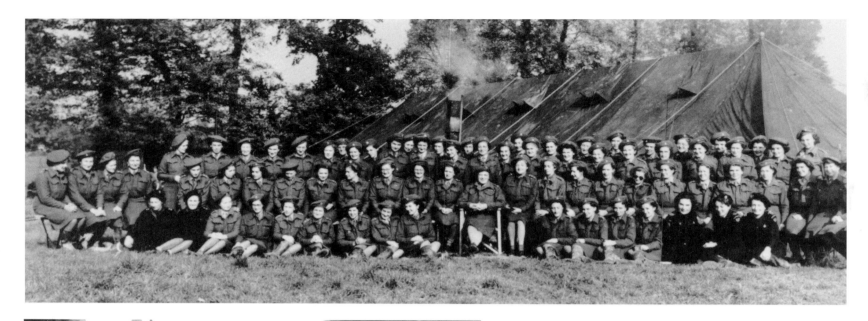

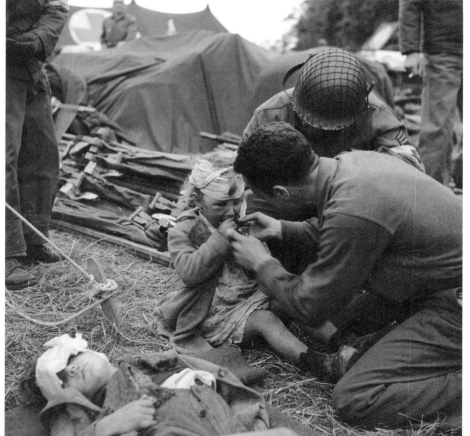

'QAs', or nurses of Queen Alexandra's Imperial Military Nursing Service, at the 101st Field Hospital at Bayeux, October 1944. There were several hospitals in the Bayeux area alone. The effective medical care that was available near the frontline meant that wounded soldiers had a much better chance of survival than in previous wars.

Two French children are treated for their injuries by US Army medics. The little girl, Genevieve Marie, was wounded in an air raid on a gun battery near Utah Beach on the night before D-Day. Thousands of French civilians were killed or injured during the fighting. (US Navy photograph)

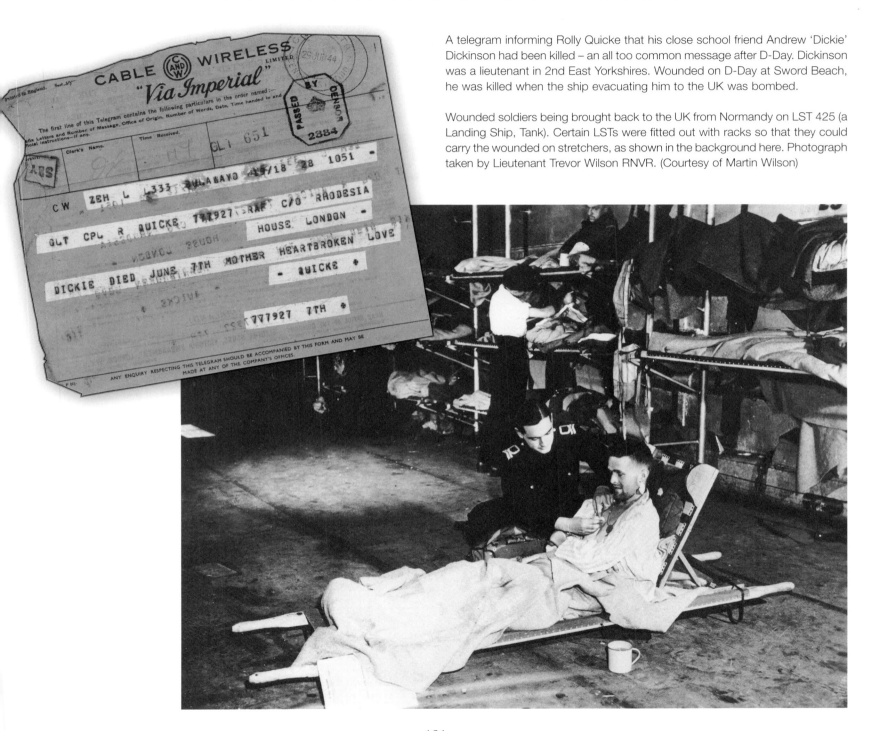

A telegram informing Rolly Quicke that his close school friend Andrew 'Dickie' Dickinson had been killed – an all too common message after D-Day. Dickinson was a lieutenant in 2nd East Yorkshires. Wounded on D-Day at Sword Beach, he was killed when the ship evacuating him to the UK was bombed.

Wounded soldiers being brought back to the UK from Normandy on LST 425 (a Landing Ship, Tank). Certain LSTs were fitted out with racks so that they could carry the wounded on stretchers, as shown in the background here. Photograph taken by Lieutenant Trevor Wilson RNVR. (Courtesy of Martin Wilson)

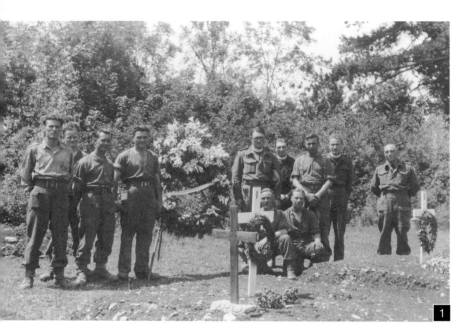

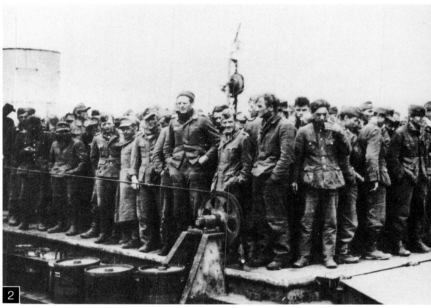

**1**

ihrer Möglichkeiten.    Ein kanadischer Pionier-Offizier sagte :

" Die V-Waffen spielen in diesem Krieg eine ähnliche Rolle wie der Tank im letzten. Sie kommen für diesen Krieg zu spät und bedürfen noch jahrelanger Weiterentwicklung, um sich von einer psychologischen Waffe in ein wahres Kampfmittel zu verwandeln. Sollte in 25 Jahren ein neuer Krieg stattfinden, und wenn es gelänge, ungestört die Vorbereitungen zu treffen, die von der deutschen Führung ursprünglich beabsichtigt waren, dann können diese Waffen im nächsten Krieg wohl ein Faktor ersten Ranges werden."

*Verunglücktes V-1-Geschoss. Ungefähr 25 v. H. der Projektile wichen von ihrer Bahn ab oder stürzten im unmittelbaren Abschussraum ab. Insgesamt 46 v. H. wurden durch Jäger und Flakbatterien abgeschossen.*

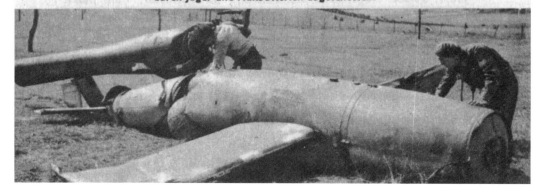

**1** A British burial party near Courseulles after D-Day. The photographer was a naval chaplain, Canon F.W. (Mike) Crooks. Troops were often buried near where they fell. After the war most scattered graves were concentrated together into the larger war cemeteries of the Commonwealth War Graves Commission and American Battle Monuments Commission that we know today.

**2** Another photograph taken on board LST 425, this one showing German prisoners of war from Normandy being brought back to the UK. In the heat of battle shootings of prisoners sometimes occurred on both sides, particularly in the bitter rivalry that developed between the Canadians and SS troops. (Courtesy of Martin Wilson)

**3** On 13 June 1944 the Germans began to fire V-1 flying bombs (doodlebugs) at the UK. This image is taken from an Allied propaganda leaflet which suggests that V-1s were ineffective. German propaganda leaflets taunted British soldiers with the damage the flying bombs were causing back home in the UK.

# seven

# FROM THE BATTLE OF NORMANDY TO VE-DAY

After D-Day the Allies sought to expand their beachhead, and the Germans tried to contain it while they brought reinforcements to the scene. The story of the Normandy landings has often tended to focus on 6 June itself, rather than the following days. It was the week or so after D-Day that was the critical period when the landings could perhaps have been defeated.

In the space available it is unfortunately not possible to mention every unit or operation that played a part in the fighting after D-Day, but this chapter will outline some key events. Allied strategy in Normandy has become a controversial subject. In its end result, the Battle of Normandy went according to the plan set out by General Montgomery beforehand. The Anglo-Canadians would push forward on the eastern side of the Allied landings, drawing the German reserves (especially the tanks of the panzer divisions) onto that flank, until the enemy forces facing the Americans were sufficiently weakened to make a break-out possible; then the whole Allied army would advance on a broad front and push the Germans back.

The battle ended with the Allies reaching the River Seine in roughly the timescale envisaged – ninety days – but the details of the campaign had not followed the plan exactly. The variations between the plan and the actual battle are one of the main causes of controversy. For example, before D-Day the capture of Caen was envisaged for the first day of the landings, but this was not achieved. In the event, the city became a pivot around which many of the Anglo-Canadian battles were fought. Montgomery's strategy was sometimes misunderstood, and a major breakthrough was expected when his intention was simply to stop German tanks from moving towards the Americans.

Soon after D-Day the Allies were warned of an impending attack through Ultra intelligence. Ultra also identified the location of the headquarters of Panzer Group West, which was to command the counter-offensive. A rapid air attack on this HQ by forty rocket-firing Typhoons and seventy-one medium bombers on 11 June cut it short.

The Allies' immediate task after D-Day was to join the five beaches together, as well as pressing further inland. The Americans had to capture the town of Carentan, which would link together Utah and Omaha. Despite considerable German reinforcements, Carentan was in American hands on 12 June. Meanwhile, forces from Omaha were pushing south towards St Lô, another key road junction, but progress through the bocage countryside was slow.

South of Gold Beach the British spotted a gap opening up between the retreating German forces of 352nd Division and the Panzer Lehr Division to the east which, if exploited, might lead to the capture of Caen. On 13 June the advance of 7th Armoured Division into this gap at Villers-Bocage was halted by a small group of heavy Tiger tanks, and other advancing German forces, forcing 7th Armoured to retreat.

Another major American target was the port of Cherbourg, to the north of Utah Beach, at the top of the Cotentin Peninsula. On 17 June US forces reached the western side of the peninsula, sealing off the defenders of Cherbourg further north. Gradually the Allied forces were forming a more coherent beachhead, but the advance to the south faced strong German resistance. By now 557,000 Allied troops had been landed in Normandy. The Allied forces were slightly stronger than those of the Germans, but given that the terrain suited the defenders they were not sufficiently superior to launch a decisive attack.

Many German infantry units – which would normally have formed the first line of defence – had suffered casualties to such an extent that tank units had to be employed to fill gaps in the frontline. This meant that the tanks could not be gathered into a reserve that could be launched in a powerful counter-attack. Although the use of tanks in this way often halted Allied attacks in the short term, in the longer term it was playing into the Allies' hands. Constant combat, and Allied naval gunfire and aircraft attacks, was

### Revealing the secret of D-Day

Even after D-Day, the Allied agent 'Garbo' played a vital part in convincing the Germans that the main Allied landing would take place in northern France. To boost his credibility it was decided that Garbo should warn the Germans of D-Day in advance! He sent a message three and a half hours before the first landings, which the Allies had calculated would not be enough time for the Germans to alert their troops. In fact, the Germans were not listening at the right time!

sapping the German units' strength. Troops and supplies being moved by rail were delayed en route, and with limited rail capacity the Germans effectively had to choose between increasing the number of troops in Normandy and supplying those who were already there. During this wearing-down process Allied units were also suffering heavy casualties, of course.

The rate at which Allied troops were being landed was already two days behind schedule when a major storm occurred from 19 to 22 June. The damage caused by the storm contributed to a delay of around one week in the Allies' overall plan for the landings. Cherbourg was captured on 27 June, but due to damage caused by the Germans its port would not operate at full capacity until September.

On 26 June Montgomery launched Operation Epsom in an attempt to outflank Caen from the west. Three days later the British reached Hill 112, a position that had a commanding view over the surrounding area. A series of fierce battles were fought over this location, ending on 23 July. The outflanking manoeuvre of Epsom did not succeed overall, but the Germans were forced to commit their newly arrived tank force, comprising two SS panzer divisions, into this fight rather than moving it against the Americans further west. At the end of the subsequent German counter-attack both sides had suffered serious losses.

By the end of June 875,000 Allied troops had disembarked in Normandy, but the British had suffered 24,698 casualties, and the Americans 37,034. The Germans now had 400,000 troops in the region. Thanks to the Allied deception plans, another 250,000 enemy soldiers were still awaiting another Allied landing in the Pas de Calais. The German forces defending Caen and facing the Anglo-Canadians (Panzer Group West) had seven armoured divisions, four infantry divisions and one Luftwaffe division. Seventh Army,

facing the Americans, had one mechanised, one panzer, three infantry, one airlanding and one parachute division.

The superiority of certain German weapons over their Allied equivalents is frequently mentioned in accounts of the Battle of Normandy. The Tiger I and Panther tanks were the most powerful German tanks to be widely used in Normandy (around 126 and 655 respectively). Their powerful guns and thick armour made them superior to most Allied tanks. Wartime research found that on average it took 2.55 shots to destroy a Tiger, but 1.63 to knock out a Sherman (the most numerous Allied tank).

In fact the majority of German tanks were equivalent to or little better than Allied tanks, and the close-range fighting in Normandy meant that advantages at long range were not an issue: ambushing the opponent from a camouflaged position was often the deciding factor. A powerful tank was of no use if it had run out of fuel or ammunition (due to the Allies interrupting German supplies), or was immobilised due to breakdowns (a frequent problem with the most formidable German tanks). Allied manufacturing capabilities were such that new tanks could be supplied relatively easily, unlike the Germans. However, these considerations were of course no comfort to an Allied soldier facing such weapons.

In the infantry's anti-tank weapons there was a similar imbalance, with the German Panzerfaust being superior to the American bazooka and the British PIAT. The German machine guns had a much higher rate of fire (1,200 rounds per minute, compared to 500 or so for Allied weapons). Other infamous German weapons were the 88mm anti-tank/anti-aircraft gun, and the Nebelwerfer multiple-barrelled mortar. Allied weaknesses in other areas were to some extent balanced by the superiority of Allied air power and artillery.

Much has been written about the relative effectiveness of German and Allied fighting men. The ability of German troops to continue fighting despite being outnumbered, or being formed into makeshift units, was certainly impressive. Many of the better-quality German units contained men with very recent experience of combat on the Eastern Front. In comparison, most Allied units arrived in Normandy with considerable training, but little or no combat experience. Too often vital tactics such as co-operation between tanks and infantry had not been sufficiently rehearsed by Allied troops in training.

The Anglo-Canadians launched Operation Charnwood on 8 July in a renewed attempt to capture Caen. Some 460 heavy bomber aircraft attacked the northern part of the city overnight, in advance of the ground troops. This caused heavy casualties amongst French civilians, and led to thousands taking refuge in nearby stone quarries and in the Abbaye aux Hommes (the church

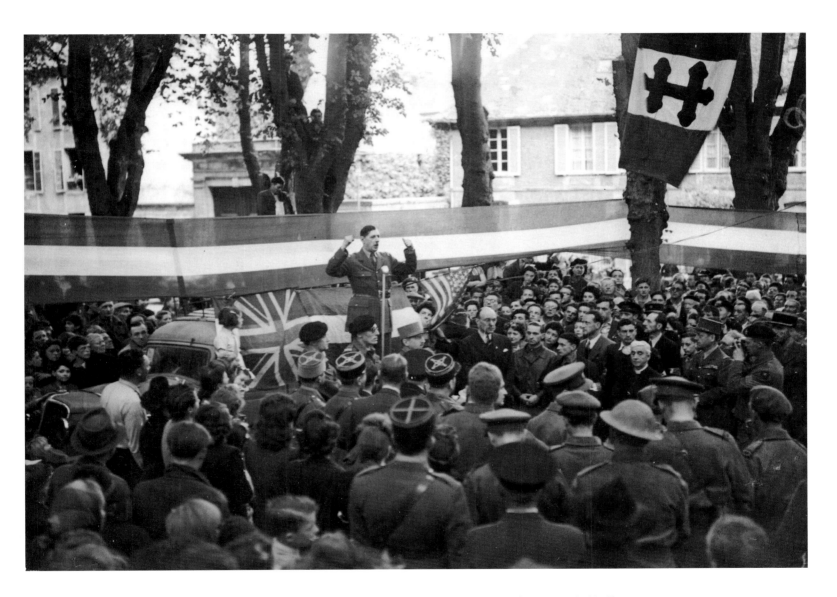

On 14 June 1944 the Free French leader, General Charles de Gaulle, landed in France and established a government at Bayeux. As can be seen here, he received a joyous welcome from the local people. (© Trustees of the Royal Marines Museum)

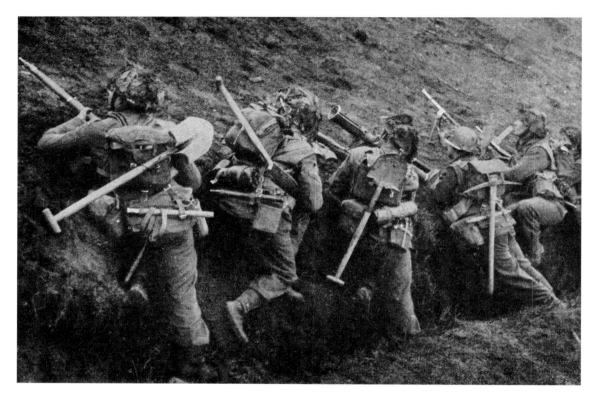

These British infantrymen carry picks and shovels for digging foxholes. A hole in the ground was the best form of protection against bombs, shells and bullets. At the centre and right are a PIAT anti-tank weapon and a Bren light machine gun, respectively, which provided vital firepower for the infantry.

in the centre of the city). British troops reached the Orne Valley south-west of Caen, which would be the scene of further hard fighting in coming weeks.

The Americans would soon launch a major offensive to advance from the area of St Lô and break through the bocage into more open terrain (Operation Cobra). Prior to that attack, the Anglo-Canadian forces would make an attack to hold German tank units away from the Americans. This was Operation Goodwood, beginning on 18 July. Three British armoured divisions with 750 tanks had been gathered in reserve, and were launched to the east of Caen. The attack began with massed heavy bomber aircraft and the fire of 750 guns, to blast a way through the German lines. Despite rapid initial advances, the British forces did not break through the entire German defensive system.

Yet Goodwood did have the effect of drawing German tank units towards the east of the Allied beachhead, and away from the next American offensive. Getting into position to launch this offensive had taken the Americans two weeks and many casualties. The Germans facing them had also suffered terribly. The Panzer Lehr division, which had started the Battle of Normandy with about 15,000 troops and 237 first-rate tanks and assault guns, was now at a strength of 3,400 men and forty tanks.

The average daily casualty rate of the Allied ground forces in Normandy actually exceeded that amongst British troops during the bloody Battle of Passchendaele in the First World War. As British casualties in Normandy mounted, the number of available replacements (and particularly infantrymen) who could take the place of those lost was decreasing. As early as the end of

June it was not uncommon for an infantry battalion to have to merge two of its companies (each with a theoretical complement of 127) because their actual strength had fallen so low. The shortages of infantry directly affected the planning for Operation Goodwood, in which heavy bombers – not infantry – were used to make a hole in the German lines, which could then be exploited by British tanks.

After Goodwood the key German forces, the panzer divisions, were distributed thus: seven facing the British (with 645 out of 835 tanks), and only two facing the Americans. The First US Army's Operation Cobra began on 25 July, again with 1,500 heavy bombers attacking German positions in advance of the ground troops.

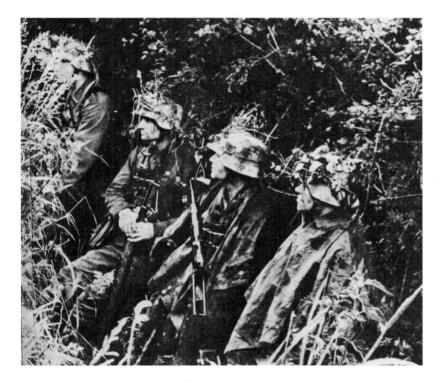

Well-camouflaged German troops somewhere in Normandy. The Germans were skilled in defence, and were aided by the difficult Normandy terrain. Areas known as the bocage proved particularly difficult for the Allies to fight through. Small fields bounded by thick hedges on top of earth banks turned each hedgerow into a small fortification.

The first days of Operation Cobra saw heavy casualties on both sides, but the Germans had fewer tanks in reserve than were faced by the British and Canadians. The overall German logistical system was now critically weakened, and this assisted the American advance. German supplies reached Normandy by two key railway routes, which at intervals were cut by Allied air raids. The main rail route to the German 7th Army (facing the Americans in the western side of the beachhead) was cut on 15 July. On 26 July, the day after Operation Cobra began, German tanks were running out of fuel, and German anti-tank guns were running out of ammunition.

By 30 July the US forces had reached Avranches, at the base of the Cotentin Peninsula, and in front of them there was little co-ordinated German resistance. They began to advance rapidly into Brittany in the west, the Loire Valley to the south, and towards Paris in the east. On 1 August command of all American forces was placed under the newly created US 12th Army Group (under Lieutenant General Omar Bradley), while Lieutenant General George Patton was given command of the new US Third Army. Urged on by their dynamic commander, Patton's forces advanced at speeds unheard of over the previous two months. At around the same time as the American breakout, British Second Army launched Operation Bluecoat, which was designed to continue holding the German panzer divisions on their front.

The German position in Normandy was fatally weakened, and the most logical choice would have been a retreat to the River Seine, which they could have used as a natural obstacle to the Allied advance. Instead, Hitler ordered a counter-attack at the town of Mortain on the evening of 6 August, using about 185 tanks that had been carefully gathered together. By striking across the line of the American advance, Hitler hoped to isolate Patton's forces. After some initial success this offensive simply drove the attackers deeper inside a rapidly closing Allied encirclement.

On the night of 7 August a Canadian and Polish attack – Operation Totalize – aimed to cut off the remaining German forces from the north by advancing to Falaise. American forces, including a French armoured division, reached Avranches on the southern side of the encirclement.

The shattered remnants of twenty-five German divisions risked being cut off in a 'pocket' that was being closed by the Anglo-Canadian forces at one edge, and the Americans at the other. The only way out was through a rapidly closing space near the town of Falaise, which gave its name to this so-called 'Falaise Gap'. The situation was made even more terrible for the Germans by the constant attacks by Allied aircraft. Canadian and Polish units sought to plug the gap, and were cut off for several days, but continued to resist and prevent or delay more enemy troops escaping.

By 22 August it was over. Although 20,000 or more German soldiers had managed to escape from the pocket, they did so without most of their heavy weapons and equipment. They left behind 10,000 dead and 50,000 prisoners. The mass of dead bodies in the 'pocket' could be smelt from aircraft flying overhead.

The first Allied troops reached the Seine on 19 August. Six days later French troops entered Paris to liberate their country's capital. The Allied landings in the south of France on 15 August had worsened an already critical situation for the Germans. By the end of August 1944 just over 2 million Allied troops and 438,471 vehicles had landed in Normandy.

Eisenhower took over direct command of all Allied ground forces from Montgomery on 1 September. The frontline moved rapidly through Belgium and into Holland. The speed of the advance began to make it difficult to keep the Allied armies supplied. A debate ensued among the Allied commanders as to whether the advance should continue on a broad or narrow front (and if the latter, which forces should lead it).

Montgomery devised a new plan to re-launch the offensive: Operation Market Garden. Rather than a steady advance on a broad front, the plan was for a sudden strike through the Netherlands to Arnhem. The plan used three airborne divisions to capture key bridges, with ground troops linking them in succession. The final bridge proved to be, in the words of the British airborne commander, 'a bridge too far', and the British 1st Airborne Division suffered heavy losses.

The stalemate resumed, resulting from the limitations of the over-extended Allied supply chain and also the continued German resistance. On 16 December American forces in the Ardennes area of Belgium were

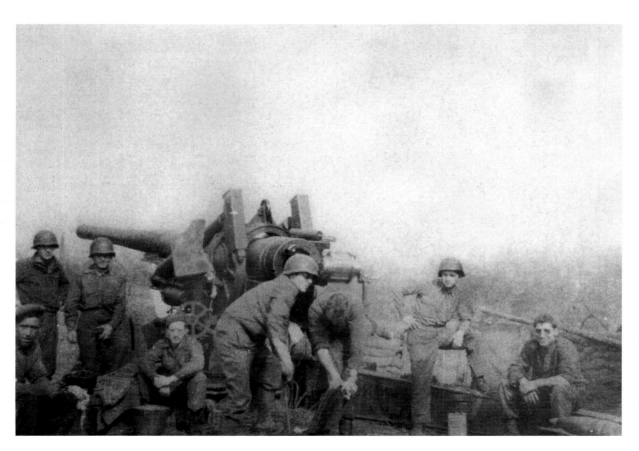

An American 'Long Tom' 155mm gun with its crew. The effectiveness and size of the Allied artillery forces was such that it was sometimes said – only partly in jest – that the main purpose of the rest of the army was to move the artillery observers forward to the next hilltop, so that they always had a clear view of the enemy.

unexpectedly hit by a huge German attack in what became known as the Battle of the Bulge. A large German force had been assembled in secret, and initially made major advances, aided by poor weather that grounded Allied aircraft. Vital road junctions at St Vith and Bastogne were defended by US troops. As the weather improved, and German fuel supplies diminished, the German attack was contained.

Although it came as a shock to the Allies, the attack had also critically weakened the German army. As the western Allies renewed their offensive in the new year, so too did the Soviets, launching a major attack on 12 January 1945. In a few weeks the Soviet armies of 2.2 million men advanced 280 miles. Although eventual defeat seemed inevitable, the Germans still fought strongly. 21st Army Group saw bitter fighting in the Reichswald Forest during February and early March. At Remagen on 7 March the first Allied troops crossed the River Rhine, a natural obstacle guarding Germany from the west. By the end of the month the Allies had footholds across the Rhine along a 200-mile front. On 16 April the final Soviet attack on Berlin began, and towards the end of the month their troops were in the heart of the city. Hitler committed suicide on 30 April. German forces surrendered shortly afterwards, and combat ceased on 8 May 1945, which was designated VE-Day (Victory in Europe Day).

There were over 209,000 Allied casualties during the Battle of Normandy, including nearly 37,000 dead amongst the ground forces and a further 16,714 deaths amongst the Allied air forces. Roughly 200,000 German troops were killed or wounded, and some 200,000 became prisoners of war. Over 15,000 French civilians were killed, mainly as a result of Allied bombing. Thousands more fled their homes to escape the fighting.

In the fighting from D-Day into Germany the western Allies had lost some 750,000 casualties, over two thirds of which were Americans. Those killed included nearly 110,000 Americans and 41,000 British and Canadians. The full number of those killed in the whole of the Second World War will never be known exactly, but has been estimated as over 46 million people.

As the Allied troops advanced – both from the west and the east – they liberated the Nazi death camps, revealing the full extent and horror of the Holocaust. The end of the war did not mean the end of the suffering for millions of people across the world: Holocaust survivors, refugees, those still held as prisoners of war, all those who had lost loved ones, not to mention the psychologically traumatised soldiers and the ravaged civilians in the wake of the advance, both east and west.

Gradually the soldiers, sailors and airmen – and women – returned to civilian life, forever changed by the experience of war. In the later years many would once again seek out the companionship of fellow veterans, and attempt to recreate the comradeship that they had known decades ago, in wartime.

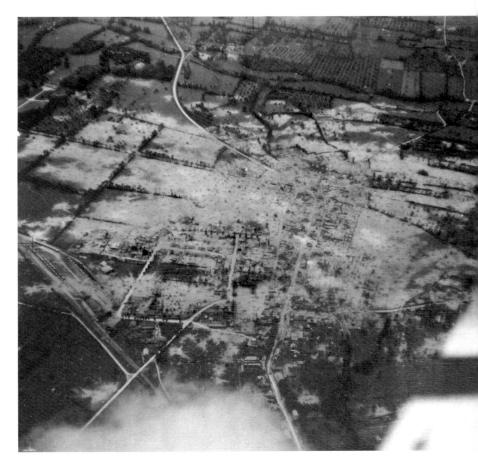

On 13 June at Villers-Bocage, as they tried to exploit a gap in the German lines, British 22nd Armoured Brigade suffered heavy losses to a small force of German Tiger tanks. The town was flattened by RAF bombers on 30 June, as seen here, during an attempt to halt a German tank attack.

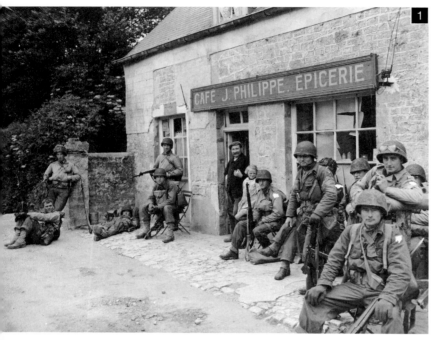

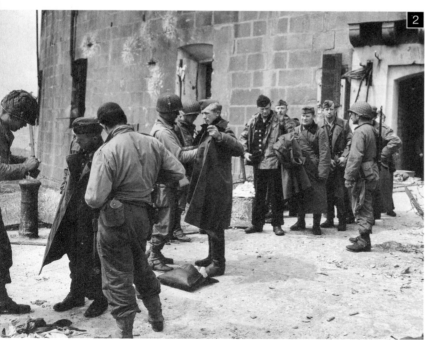

**1** Men of the US 90th Infantry Division pause at Baudienville in the Cotentin Peninsula, probably on 7 June. This division suffered heavy casualties in the campaign to seal off the peninsula and prevent the Germans from being able to reinforce the important port of Cherbourg to the north. (US Navy photograph)

**2** US soldiers search German prisoners of war after the capture of the former arsenal at Cherbourg. Once the Americans had captured the city on 29 June they found that the Germans had destroyed or booby-trapped its port facilities. This delayed the use of the port by Allied shipping.

**3** Rockets fired from a Typhoon aircraft against enemy positions on Carpiquet Airfield, to the west of Caen. The airfield was bitterly fought for by the Canadians during the Allied advance on Caen. Typhoons carrying rockets like these were a major weapon against German tanks.

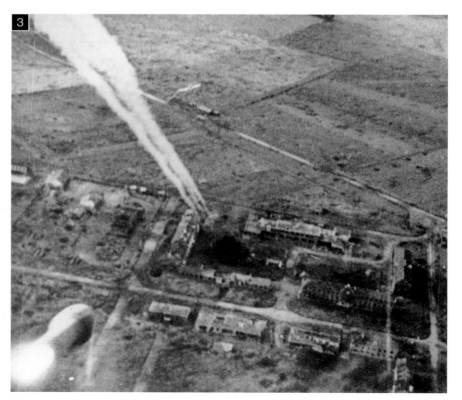

### Penicillin

In previous wars many wounded soldiers died not directly from their wounds but as a result of later infections. Penicillin was discovered in 1928, but was not thoroughly investigated as a means of infection control until 1939. During the Second World War methods were developed for mass-producing the quantities of penicillin required by the armed forces, and huge supplies of it were stockpiled for treating wounded troops from D-Day.

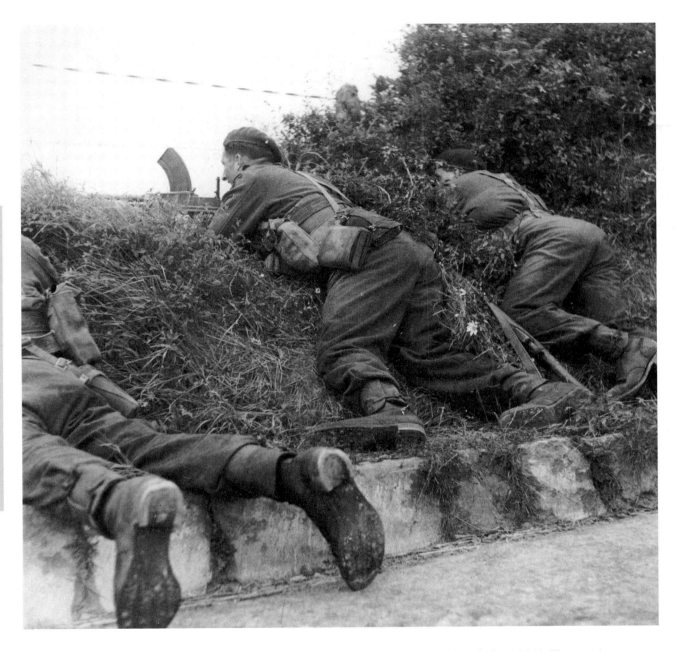

Royal Marines of No.45 Commando in action by the side of a Normandy road, June 1944. The man in the centre has a Bren light machine gun, typically used to provide supporting fire while other members of the unit attacked the enemy. (© Trustees of the Royal Marines Museum)

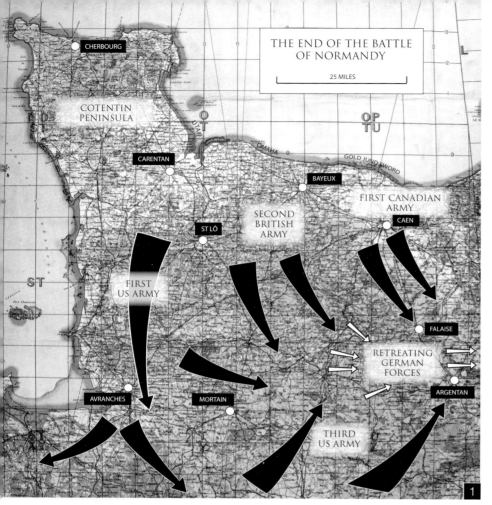

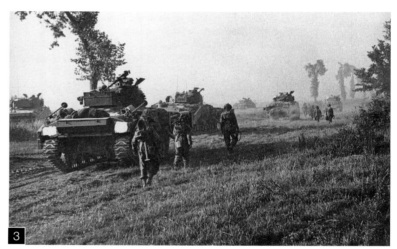

1  This map shows in simplified form the final Allied offensives in Normandy. In the west the US forces attacked south from near St Lô (Operation Cobra), breaking through to the east and west. The British, American and Canadian armies then surrounded the remaining German forces, despite a German counter-attack at Mortain, and many German troops were killed or captured in the Falaise pocket.

2  British and Canadian troops are met by French civic and resistance leaders as Caen is liberated, 9 July 1944. The buildings behind them indicate the damage sustained by the city during the heavy fighting.

3  British tanks of 27th Armoured Brigade and infantry of 3rd Division advance to the east of Caen on 18 July, on the first day of Operation Goodwood. This division protected the eastern flank of this major British tank attack.

4  Men of 3rd Canadian Division rest at Caen's train station after the liberation of the city. They are eating and drinking from their standard issue mess tins and mugs. (Conseil Régional de Basse-Normandie / National Archives Canada)

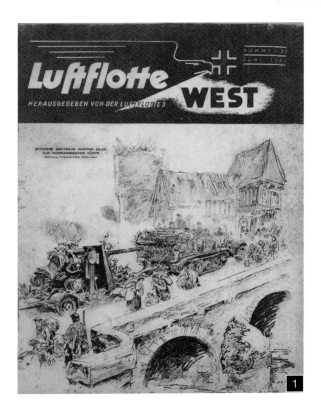

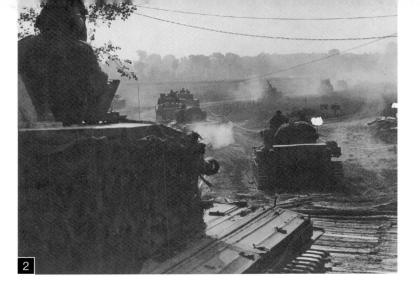

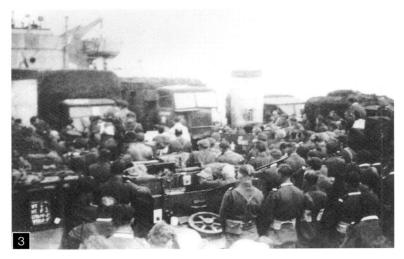

**1** The cover of the Luftwaffe's magazine in Western Europe from June 1944 depicts German reinforcements heading for Normandy. On the left is an 88mm anti-aircraft gun which was also greatly feared by Allied troops for its effectiveness as an anti-tank or anti-personnel weapon.

**2** British tanks move forward during Operation Goodwood (18-21 July), to the east of the River Orne. This major attack involved 750 tanks from three British armoured divisions: Guards, 7th and 11th. It did not achieve its full territorial objectives but did draw German reserves away from Operation Cobra.

**3** Members of 1st Polish Armoured Division hold a church service on board LST 425 while crossing the English Channel to go to Normandy. The division's troops played a key role in preventing German forces escaping encirclement in the Falaise pocket on 19-21 August 1944. Photograph taken by Lieutenant Trevor Wilson RNVR. (Courtesy of Martin Wilson)

**4** This vertical aerial photograph, taken at night during the Battle of Normandy, illustrates some of the German army's difficulties. Deadly Allied air attacks in the daytime made the night the safest time to move troops. These German vehicles (mostly horse-drawn, which reflects the Germans' limited fuel supply) are moving past a heavily shelled crossroads.

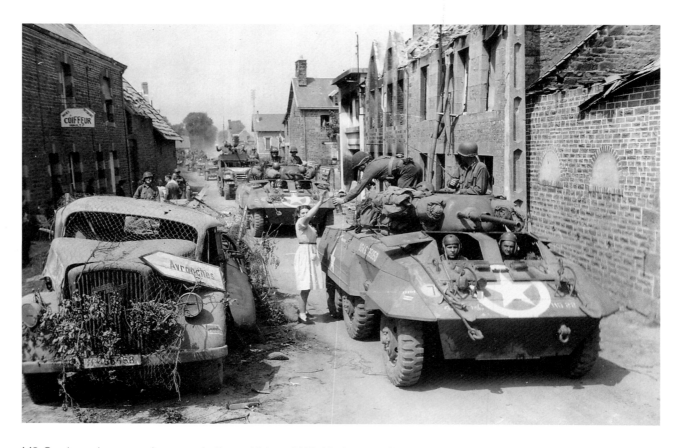

M8 Greyhound armoured cars and other vehicles of US 4th Armored Division pass through Le Repas, about twelve miles north of Avranches on 31 July 1944. The division was one of General George Patton's key units, and soon after this made rapid advances into Brittany. (Conseil Régional de Basse-Normandie / US National Archives)

## Hitler's jet aircraft

Nazi leader Adolf Hitler committed huge resources to so-called 'wonder weapons', several of which might have affected D-Day had they been developed in time. These included two jet aircraft that could have used their high speeds to evade the more numerous Allied fighters. The Arado Ar 234 had a top speed of around 460mph, and in its first operational photographic reconnaissance flight on 2 August 1944 it photographed the entire Normandy beachhead. Had it been available before D-Day the Germans might have discovered where in the UK Allied troops were assembling. Hitler wanted the Messerschmitt Me 262 jet fighter (maximum speed 540mph) to be capable of bombing Allied invasion forces, but it was not fully operational until 1945.

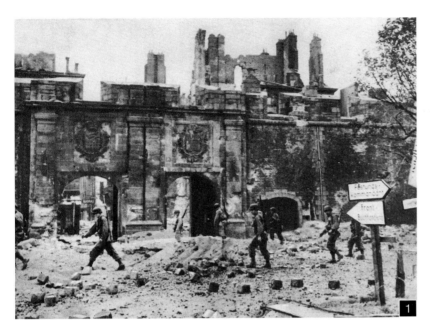

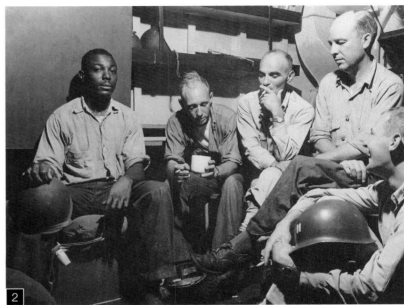

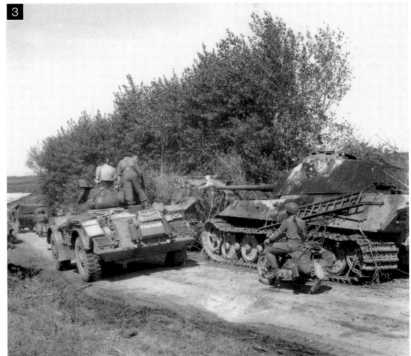

**1** US troops at St Malo, reached in mid-August 1944 as the Americans began to advance into Brittany. The city was left in ruins after its liberation from German occupation.

**2** Five hours before the landings in the south of France began on 15 August, US sailors contemplate the likely outcome. They include members of a demolition unit that would prepare the way for following troops. The landings added to the Germans' critical situation in France. (US Navy photograph)

**3** A Staghound armoured car of the Canadian 18th Armoured Car Regiment passes a knocked-out King Tiger tank. This was the most powerful German tank in Normandy, but fortunately for the Allies very few were used there. The location is near Vimoutiers, beyond the Falaise Gap, on 22 August 1944. (Conseil Régional de Basse-Normandie / National Archives Canada)

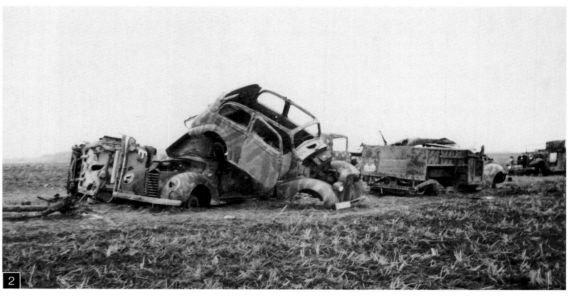

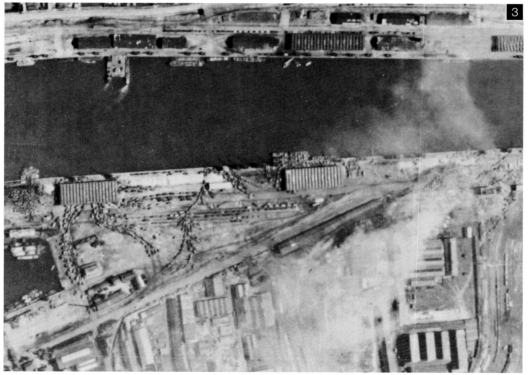

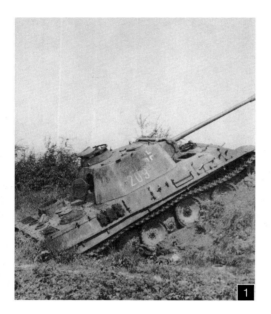

**1** A Panther tank that has met its end (the crew have apparently escaped through the open hatches). The Panther was an effective German tank, easily a match for most Allied tanks, and 655 were used in Normandy.

**2** Wrecked German vehicles lie in heaps near Falaise, thrown about by Allied shelling or air attacks, which caused terrible destruction to the retreating German forces.

**3** This vertical aerial photograph, taken on 26 August, shows queues of German vehicles waiting to cross the River Seine on a ferry during the retreat from the Falaise pocket. After this photograph was taken the area was swiftly bombed by the Allies.

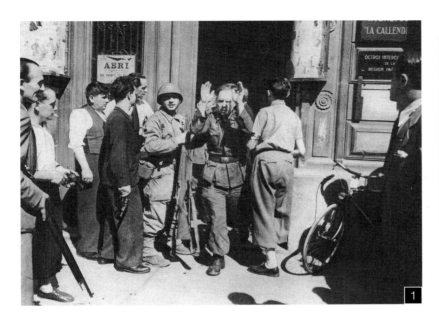

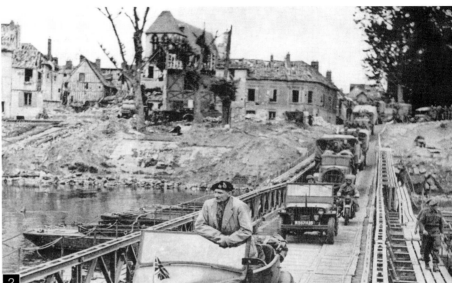

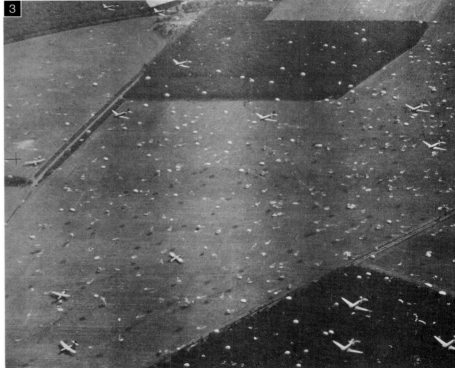

**1** French soldiers, and members of the Resistance, receive the surrender of German troops during the liberation of Paris. French troops were specially tasked with liberating their capital city, which took place on 25 August.

**2** On 1 September 1944 Bernard Montgomery crossed the River Seine. On the same day he was promoted to the rank of field marshal. Eisenhower took over the overall command of the Allied ground forces, while Montgomery still commanded 21st Army Group, now comprising British Second Army and Canadian First Army.

**3** A photograph taken from the air showing the British airborne landings in progress near Arnhem on 17 September 1944. Dakota aircraft fly overhead, dropping troops. Hundreds of parachutists and a small number of gliders can be seen.

## The Polish troops in Normandy

Soldiers from many nations fought as part of the Allied armies in Normandy, and the case of the Poles illustrates the hardships that they had often gone through even before D-Day. After the German defeat of Poland in 1939 tens of thousands of Poles escaped to Allied countries, many taking part in the fighting in 1940. Following the fall of France, 24,000 of these men reached the UK, and from these exiles and also from Poles who had emigrated before the war, was constructed the 1st Polish Armoured Division, which fought in Normandy towards the end of the battle. After the war, many chose not to return to Soviet-dominated Poland.

**1** British aircraft fly overhead on their way to drop airborne troops during 21st Army Group's crossing of the River Rhine on 24 March 1945 (Operation Plunder). The first Allied troops reached the Rhine on 7 March, and by the end of the month they were across and advancing on a wide front.

**2** A house seen by British soldier Edwin Crowe in the Goch area of Germany during the last months of the war. The German graffiti indicates a continued spirit of German resistance: it translates as 'stick it out, fight, win' and 'One people, one empire, one Führer (leader)'.

**3** A half-built V-2 rocket in the underground V-weapons factory at Nordhausen, Germany, seen after it was captured by Allied forces. The factory labourers were all from the nearby Dora concentration camp, and conditions there were unimaginably harsh. As the Allies advanced, their troops liberated the concentration camps and saw first-hand evidence of the Holocaust.

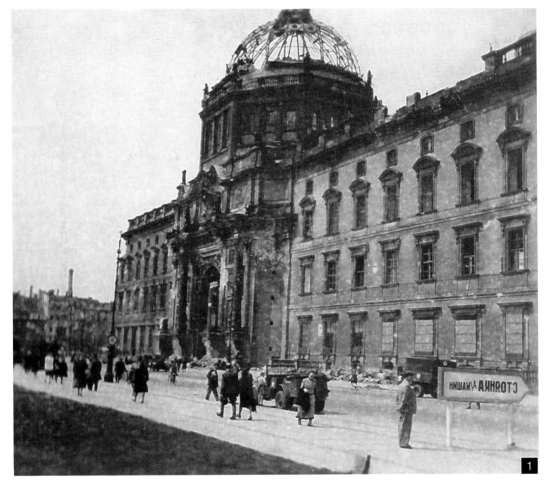

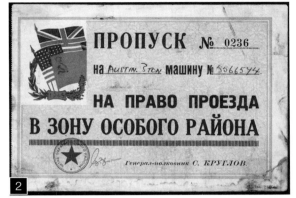

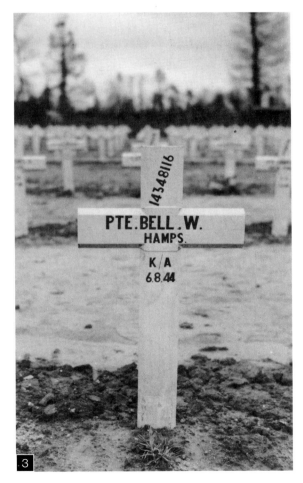

**1** The Reichstag (parliament building) in Berlin just after the end of the war, photographed by Ken Pitt, a British soldier. Berlin was captured by the Soviets, but its control was subsequently divided up between USA, Britain, France and the Soviet Union.

**2** A vehicle pass issued to Arthur Wichall by the Soviets when he served as a driver for the British contingent at the Potsdam Conference in July 1945. The conference was held by the Allies to discuss the borders of post-war Europe. The seeds of the Cold War were already sown.

**3** A wooden cross marks the grave of Private William Bell of 1st Hampshires, who was killed on D-Day. Until August 1944 his family were only told that he was 'missing'. The end of the Second World War did not mean an end to the pain and suffering that war had brought to millions of people across the world.

## ABOUT THE PHOTOGRAPHS

The majority of the photographs and other images used in this book are from the collections of the D-Day Museum, which is part of Portsmouth Museums & Records Service and Portsmouth City Council. The D-Day Museum is the UK's only museum that has the sole aim of telling the story of the Normandy Landings. For enquiries about these photographs, or if you would like to donate material to the museum (or let us copy it), please contact:

Military History Officer
City Museum & Records Office
Museum Road
Portsmouth, PO1 2LJ
United Kingdom

Tel. 023 9282 7261
www.ddaymuseum.co.uk

## ACKNOWLEDGEMENTS

The author would like to thank the following: my wife Bryony for her support during the writing of this book; Portsmouth City Council, my employer, for letting me base the book on the collections of the D-Day Museum and Portsmouth Museums & Records Service; the many Normandy veterans (particularly members of the Portsmouth Branch of the Normandy Veterans Association) who have talked to me about their experiences and given other assistance; Viscount Montgomery for his Foreword; Alan Wakefield for his comments on the drafts; and the many other people, too numerous to name individually, who have assisted me during the writing of this book.

Since the D-Day Museum opened in 1984 several thousand members of the public have given D-Day-related material to the museum's collections. It has only been possible to use a proportion of these items in this book, but the museum is grateful to everyone who has donated such material. Without their generosity, this book would not have been possible.

Copyright to some of these photographs belongs to other organisations or individuals, and the author is grateful to have received permission for their use.

Images used in the book were kindly provided by the following:

Mr J. Roy Arden (Mr Len Williams photos); Mr J.H. Barfod; Mr Robin Beckett; Mr M.H. Bibby; Mr David Bright; Mr W.E. Brown; Mr G.P. Cashmore; the Reverend G.W.H. Champness; Conseil Régional de Basse-Normandie (US National Archives & National Archives Canada photos, www.archivesnormandie39-45.org); Mr R. Cowey; Canon F.W. (Mike) Crooks; Mrs Eva Crowe (Mr Edwin Crowe photos); Commander Rupert Curtis; Mr K. Edmonds Gately; Mr Anthony R. Elliot; Mr R.A. Elliott; Mr John Ellis (photos from Mr John Ellis, Mr Leslie Fowler and Mr Heather); Mr A.R. Freemantle; Mrs B. Gaudry; Air Commodore Andrew Geddes; Mr G.J. George; Lieutenant Commander Fred Gerretson (USN Combat Photo Unit 8 photographs); Mr Ron Grant; Mrs J.E. Hamilton; Mr Ian Hammerton; Mr Robert Hare; Mr Philip M. Hedley-Prole; Professor André Heintz; Mr R.V. Hill; Major & Mrs D. Holman (D-Day & Normandy Fellowship); Mr C.J. Holness; Lieutenant Commander G.B. Honour; Mrs J. Hurston; Mr D.T. Huxtable; Ms Seran Kubisa; Mr E.G.R. Lea; Mr G.E. Laughton; Mr Rowan le Bentall; Mrs M. Lyons; Mr David Maber; Mr Ron Manning; Mr Frank Martin; Mr R.C. Martin; Mr S. Mincher; Mr Mitchell; Mr W.M. Morgan; Musée du Debarquement, Arromanches; Mrs Audrey Nabarro; Mrs L.E. Ormston; M. Patrick Peccatte & M. Michel Le Querrec (www.flickr.com/photos/photosnormandie); Mr Ken Pitt, Mr K.W. Peeling; Mr Oliver H. Perks; Mr L.A.C. Pratt; Lieutenant Colonel R.H.C. Probert; Mrs J. Quicke; Mr Alan Ritchie; Mr Robert Rule; Royal Naval Museum, Portsmouth; Royal Marines Museum, Portsmouth; Mrs Gabrielle Russwurm; Mr C.W. Salter; Dr J. Nuttall Smith; Mr C.J. Stares; Mr Mark Stedman; Mr R.F. Stubbs; Tangmere Aviation Museum; Mrs Joy Timbrell (Lieutenant Phillip Winkley photos); Mrs Angela Tilley (Commander Eric Middleton photos); *The News*, Portsmouth; Mr Warren Tute; Mr Martin Waarvick; Mrs C. Ward; Mr Brian Warner; Mr Malcolm Waterman; Mrs D. White; Mr Martin Wilson (Lieutenant Trevor Wilson photos); Miss B. Yates.

## SELECT BIBLIOGRAPHY

Books that were particularly useful in the writing of this volume include:

Georges Bernarge, *Gold Juno Sword* (Editions Heimdal, 2003)

Stephen Brooks and Eve Eckstein, *Operation Overlord. The History of D-Day and the Overlord Embroidery* (Ashford, 1989)

John Buckley (ed.), *The Normandy Campaign 1944. Sixty years on* (Routledge, 2006)

David Chandler and James Lawton Collins (eds.), *The D-Day Encyclopaedia* (Simon & Schuster, 1994)

Ian Daglish, *Operation Epsom: Over the Battlefield* (Pen & Sword, 2007)

L.F. Ellis, *Victory in the West. Volume I: The Battle of Normandy* (HMSO, 1962)

Jonathan Gawne, *Spearheading D-Day: American Special Units in Normandy* (Histoire & Collecions, 2001)

Max Hastings, *Overlord: D-Day and the Battle of Normandy 1944* (Michael Joseph, 1984)

John Man, *The Penguin Atlas of D-Day and the Normandy Campaign* (Penguin, 1994)

No given author, *Operation Overlord. From its Planning to the Liberation of Paris* (Salamander, 1999)

Winston Ramsey (ed.), *D-Day Then and Now* (two volumes), (Battle of Britain Prints International, 1995)

S.W. Roskill, *The War at Sea 1939-1945, Volume 3: The Offensive, Part II: 1st June 1944-14th August 1945* (HMSO, 1961)

David Stafford, *Ten Days to D-Day* (Little, Brown, 2003)

Warren Tute, *D-Day* (Sidgwick & Jackson, 1974)

Various authors, the *Battlefield Europe* series of battlefield guidebooks (Pen & Sword, 1999-2002)

Various authors, the *Battle Zone Normandy* series of battlefield guidebooks (Sutton, 2004)

Niklas Zetterling, *Normandy 1944: German Military Effectiveness, Combat Power and Organizational Effectiveness* (J.J. Fedorowicz, 2000)